Historic England

The Black Country

Andrew Homer

AMBERLEY

Acknowledgements

The majority of pictures are from the Historic England Archive, but I am also very grateful to the Black Country Living Museum, *Express & Star*, Dudley Archives & Local History Service, Sandwell Community History and Archives Service, and Wolverhampton Archives. Also, my grateful thanks go to Ashley Dace, Barry Randall, Dave Marsh and Richard Law.

First published 2019

Amberley Publishing
The Hill, Stroud, Gloucestershire, GL5 4EP
www.amberley-books.com

ISBN 978 1 4456 9125 1 (print)
ISBN 978 1 4456 9126 8 (ebook)

Typesetting by Aura Technology and Software Services, India. Printed in Great Britain.

Contents

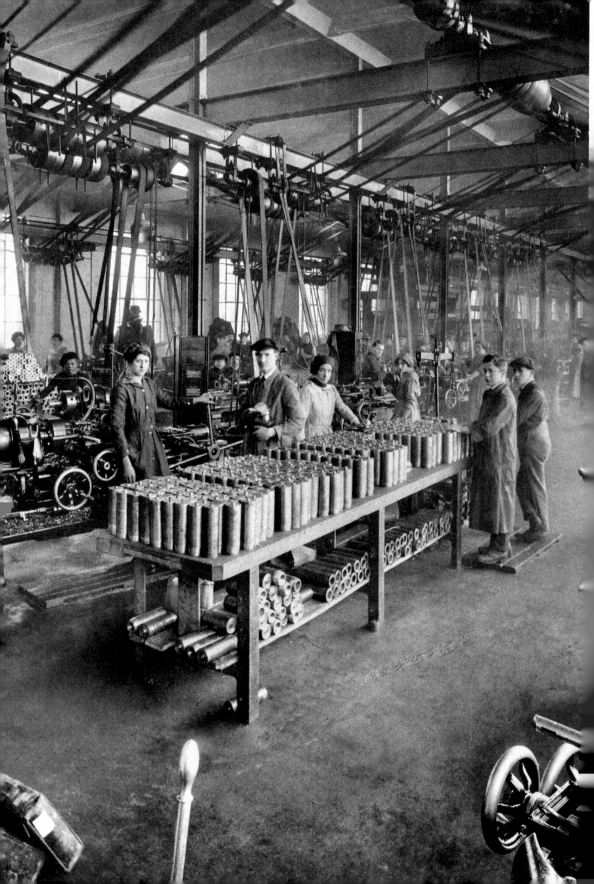

Introduction

Any book with Black Country in the title is challenged with trying to establish exactly where it is. Official borders will not be found on any map, and even Ordnance Survey, who now recognise the area, will do no more than print the title between West Bromwich and Dudley. There is no shortage of opinion. Ask anyone born and bred in the Black Country and they will be more than happy to tell you exactly where it is. The problem is, and always has been, getting any kind of consensus among the proud folk who live here as to where the borders actually are.

The exact same problem faced Elihu Burritt, American consul to Birmingham in the 1860s, when he wrote an early book on the region, published in 1868. To hedge his bets, he chose to call it *Walks in the Black Country and its Green Borderland*. Elihu Burritt is famous for the first line of chapter one where he described the area as being 'black by day and red by night'. Black by day because of the continuous pall of black smoke that hung over it, and red by night because of all the forges and furnaces that illuminated the skyline. It is most likely that this continuous pall of black smoke and the associated pollution gave the area its name, although this is also subject to local opinion!

With a few exceptions the pictures in this book are taken from the Historic England Archive and a fairly broad view is taken that the Black Country is the area roughly encompassed by the four boroughs of Dudley, Wolverhampton, Sandwell and Walsall. The content has very much been driven by what there is to be discovered within the archive and as such is a fascinating and sometimes surprising mix of the familiar and the not so familiar. Thousands of people visit Dudley Zoo and Castle every year, but how many realise they are also visiting a set of modernist buildings that are so rare they have achieved World Monuments Fund status. The first railway locomotive to run in America was designed and built right here in the Black Country. The area is usually associated with mining and industry, but the Black Country also played its part in significant historic events such as the Gunpowder Plot and the restoration of a Stewart king to the throne of England.

Around the Towns

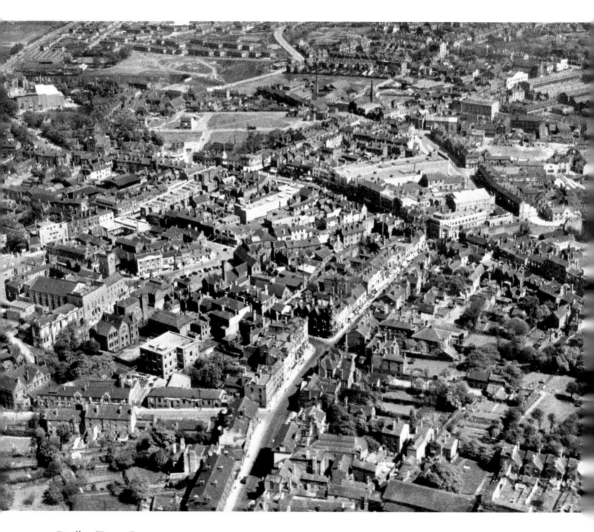

Dudley Town Centre
Just below the centre of the image is the Victorian Gothic-style former Crown public house, on the corner of Wolverhampton Street. Built of red brick by the Mitchell and Butler Brewery in 1895, the building featured an impressive turret and spire. Following Wolverhampton Street up to the right, the imposing 1930 Grecian-style Barclays Bank building is on the High Street. To the top left the art deco Odeon Cinema on Castle Hill is under construction. (© Historic England Archive. Aerofilms Collection)

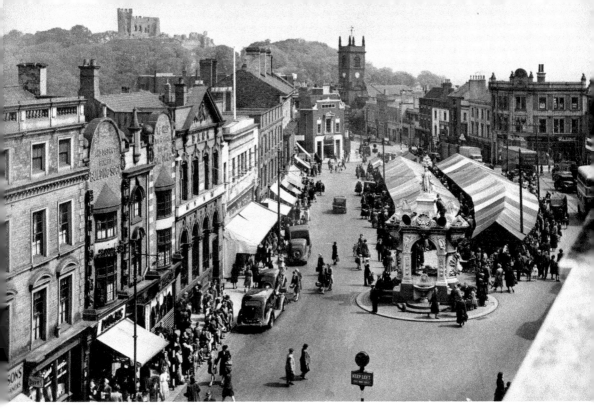

Dudley Marketplace

When this picture was taken around 1950, Dudley had been a thriving market town for centuries. The earliest references to Dudley being a borough and holding a royal charter for a market are from the thirteenth century. At this time Roger de Somery had a licence to 'crenellate' or fortify the castle, which can be seen in the background. The development of Dudley as a borough would have supported Roger de Somery's plans for the castle. (Historic England Archive)

Wolverhampton

It seems likely from a document dated 1204 that Wolverhampton had established a market earlier than Dudley. However, an official royal charter wasn't granted until 1258 by Henry III for Giles de Erdington, Dean of Wolverhampton, to hold regular markets. In the centre of the picture is Queen Square and Prince Albert's statue. Immediately above is St Peter's Church, with the now demolished Edwardian market hall immediately to the left of the church tower. (© Historic England Archive. Aerofilms Collection)

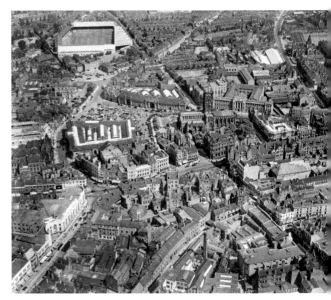

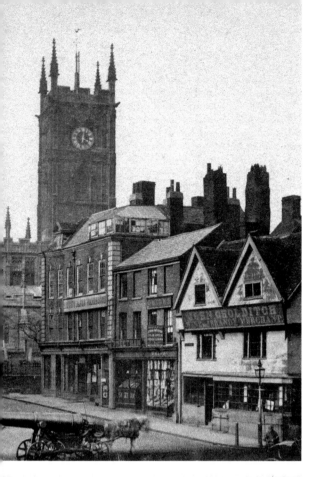

Queen Square Looking Towards
St Peter's Church
Pictured around 1880, the building on
the corner belongs to wine merchant
John Cholditch. He became one of
Wolverhampton's very first councillors
after a charter of incorporation was
granted by Queen Victoria in 1848. This
replaced the former town commissioners
with elected council members. John
Cholditch was elected to represent
St Peter's Ward in the brand-new
Wolverhampton Council. (Historic
England Archive)

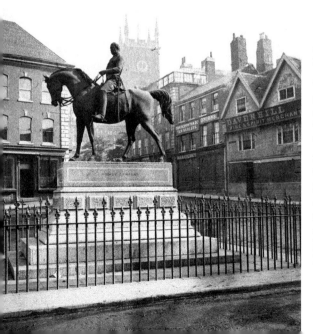

Prince Albert's Statue, Queen Square
When Prince Albert died in 1861,
Queen Victoria approved a statue to be
erected by public subscription in High
Green, as Queen Square was then called.
The bronze statue was designed by
T. Thorneycroft. When invited to unveil it
in 1866, nobody expected Queen Victoria
to accept. In the event, it was the queen's
first public engagement after Albert's
death. Thorneycroft allegedly committed
suicide the day after because the crowd
disapproved of the horse, although
he actually died in 1885. (Historic
England Archive)

Right: The Star & Garter Royal Hotel, Victoria Street
Originally a sixteenth-century house on Cock Street, it later became the Star & Garter Royal Hotel after an incident in 1642 during the English Civil War. Charles I was given shelter there by Madame St Andrew, a relative of the owner Henry Gough. By 1836, the inn it had become was extensively rebuilt. Pictured around 1880 on the renamed Victoria Street, it was one of Wolverhampton's premier hotels. It finally closed in 1961 and was demolished to make way for the Mander Centre in 1964. (Historic England Archive)

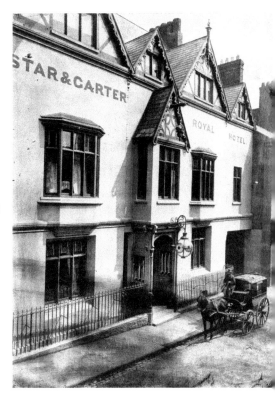

Below: Edwardian Wholesale Market
Wolverhampton's Wholesale Market is seen here under construction in this image from 1902. The brick and terracotta building was designed by borough engineer J. W. Bradley, and was built opposite the Retail Market Hall, which originally opened in 1853. The land between the two market halls was known as the 'Market Patch' and was used for both markets and fairs. The Wholesale Market was demolished in 1975 to make way for the new Civic Centre. (Historic England Archive)

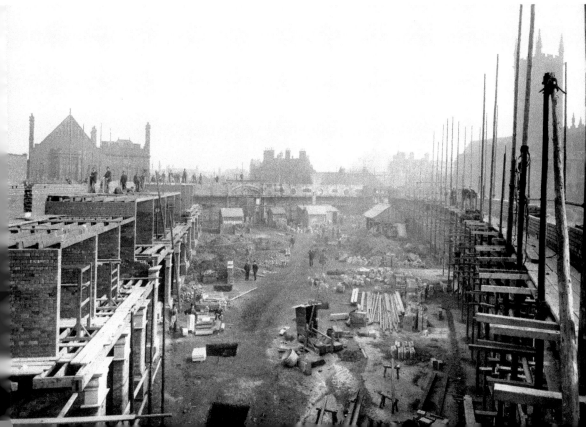

H. Blackham & Son, Lichfield Street
During the later Victorian period, Wolverhampton became a leading centre of optometry and the creation of high-quality optics for a wide range of purposes. A young Henry Blackham set up his optometry business at Snow Hill in 1863. By the mid-1890s Henry had moved to the building pictured at No. 44 Lichfield Street, specialising not just in spectacles but also optical instruments such as microscopes and telescopes. In 1895, Henry and twelve other leading optometrists founded the British Optical College Association, now called the College of Optometrists. (© Historic England Archive)

Beatties Department Store
The iconic Wolverhampton Beatties department store corner building started life as a Burton's clothing store and was designed in their own art deco style. Beatties itself was established in 1877 by James Beattie as the Victoria Draper Supply Store. Beatties flourished from the 1920s onwards and in Wolverhampton had frontages on both Victoria Street and Darlington Street. At its height Beatties had twelve stores, including one in Dudley. The popular department store chain was acquired by House of Fraser in 2005. (© Historic England Archive)

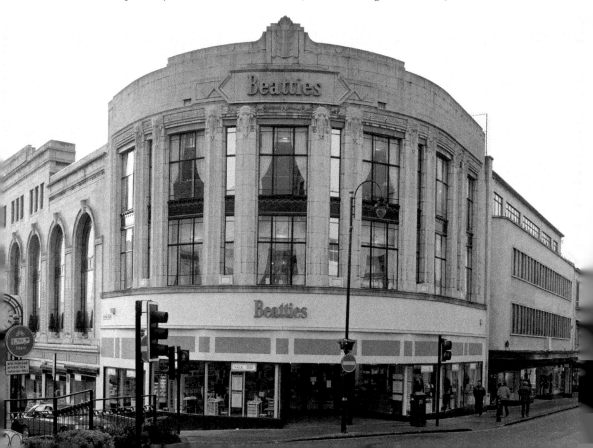

Wolverhampton Mander Centre
The name Mander is synonymous with
the manufacture of paints and varnishes.
Mander Brothers occupied a 4.5-acre site in
Wolverhampton that they developed into the
Mander Shopping Centre, opening in 1968.
In common with many similar developments
at the time, architect James Roberts
employed the use of exposed concrete. The
Woolworths store pictured was the biggest
in the country at the time and covered three
floors. The store closed in 2008. (Historic
England Archive)

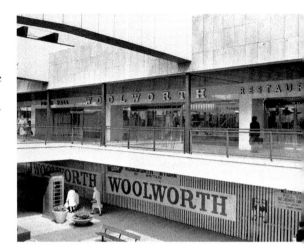

Bilston Town Centre
It is hard to imagine Bilston as the agricultural village and local market it once was. From the
1700s onwards, Bilston was very quickly subsumed by the Industrial Revolution. In 1825 an
Act of Parliament officially established a public market. Dominating the centre of the picture
is the covered market hall, which was built in 1891 at a cost of £10,000. When it opened on
Church Street it was even lit by electricity. The old market hall was demolished to make way
for town centre redevelopment. (© Historic England Archive. Aerofilms Collection)

Bilston Town Hall
Pictured around 1890, Bilston Town Hall was completed in 1873 to a design by architects Bidlake and Lovatt. The building was also intended as a library, which was extended in 1880. As well as serving the needs of Bilston Urban District Council, which became Bilston Borough Council in 1933, the building also hosted regular dances in the ballroom and was also used to show films in Wood's Palace Cinema, as it was known. It fell into disuse in 1996, but is now preserved thanks mainly to local pressure. (Historic England Archive)

Darlaston Town Centre
Darlaston was an agricultural settlement prior to the Industrial Revolution. Pictured in 1926, the large building to the bottom left on Pinfold Street is the Wesleyan chapel, which opened in 1810, with the Wesleyan school built next door in 1846. To the top right is the Slater Street Methodist Church, which was demolished in 1979. Below the church and immediately opposite Victoria Park bandstand is the Town Hall (1887) and post office (1912) on the opposite corner of Victoria Road. (© Historic England Archive. Aerofilms Collection)

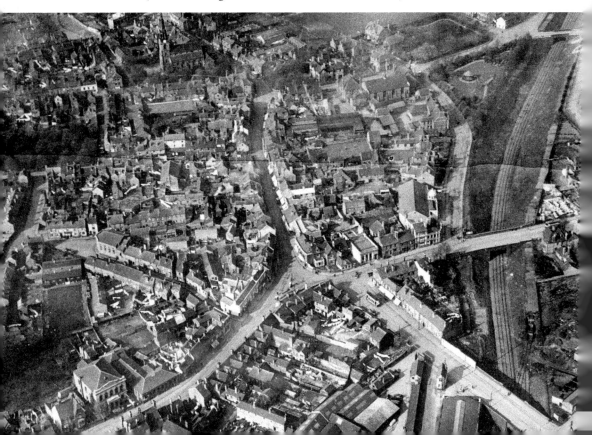

Right: Willenhall Marketplace Clock Tower
This clock tower is a memorial to Dr Joseph Tonks, who was born in Willenhall and graduated in medicine at Queens College, Birmingham in 1879. He worked unstintingly to ease the suffering of the poorer people of Willenhall, earning himself the nickname of 'the poor man's doctor'. As a result of injuries sustained in a ballooning accident in 1888, he died in 1891 aged just thirty-five. The clock tower and drinking fountain was purchased using donations to the memorial committee and inaugurated in 1892. (© Historic England Archive)

Below: West Bromwich High Street
The High Street runs along the bottom of this aerial photograph. The ornate terracotta building at the centre of the High Street is the Grade II listed offices of the Kenrick and Jefferson Printing Works, built in 1883. Originally called the Free Press Company, the name was changed to Kenrick and Jefferson in 1885. By the late 1990s the firm had been sold off, but the listed 1883 building is due for sympathetic transformation into shops and apartments. (© Historic England Archive. Aerofilms Collection)

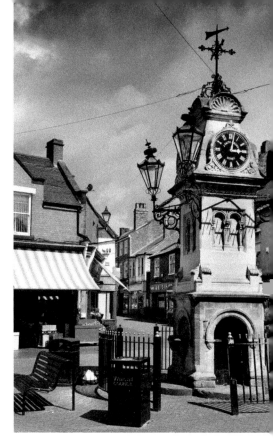

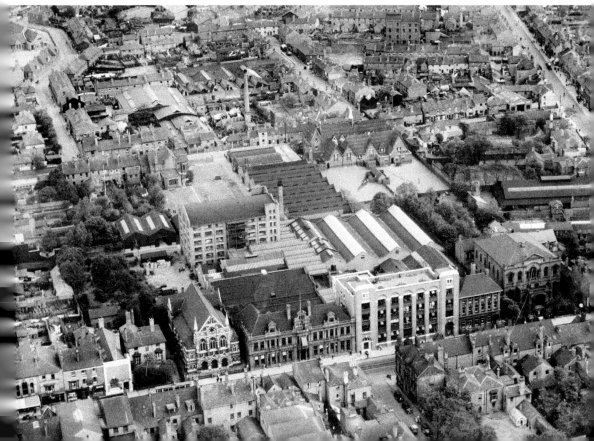

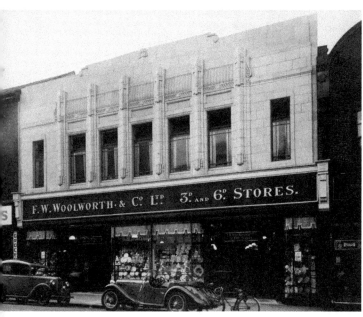

Left: F. W. Woolworth & Co., High Street, West Bromwich Woolworths was a familiar sight on almost every high street. The first F. W. Woolworth store in the United Kingdom opened in Liverpool in 1909. As can be seen from this 1930s photograph, Woolworths traded as the 'threepenny and sixpenny stores', which proved immensely popular. The art deco-style West Bromwich store opened in 1922, eventually moving to Princess Parade until finally closing its doors in 2008. (Historic England Archive)

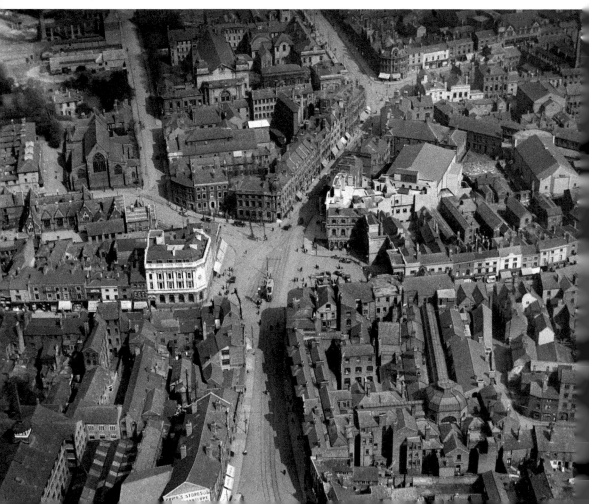

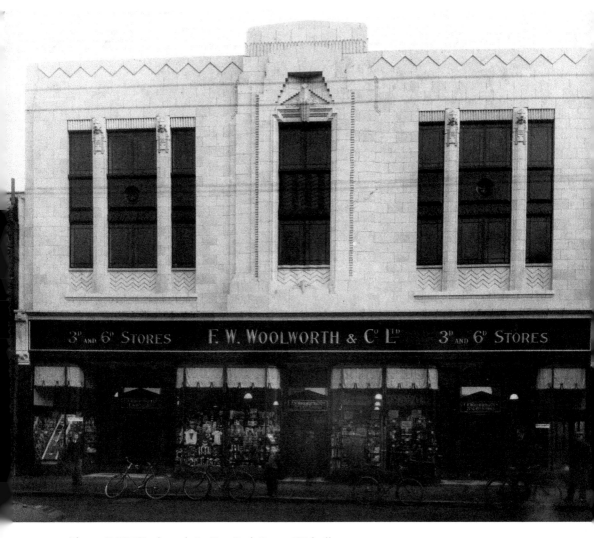

Above: F. W. Woolworth & Co., Park Street, Walsall
The Walsall branch of Woolworths was opened in 1915, but the art deco-style building pictured here replaced the original around 1920. The building featured lion's heads at the top of the windows in support of British-produced goods following the First World War. The frontage was modernised in the 1970s, but the store closed in the 1980s to be later relocated to Walsall Town Wharf. (Historic England Archive)

Opposite below: Walsall Town Centre
The building just left of centre is Lloyds Bank, built in the baroque style around 1900. On the opposite side of the square is the country's first woman to be commemorated by a statue, apart from a royal, which was unveiled in 1886. Dorothy Windlow Pattison was Walsall's very own Sister Dora. She was renowned particularly for nursing victims of the Birchills Iron Works blast furnace explosion, of a scarlet fever outbreak and for supporting families during the Pelsall Colliery flood disaster. (© Historic England Archive. Aerofilms Collection)

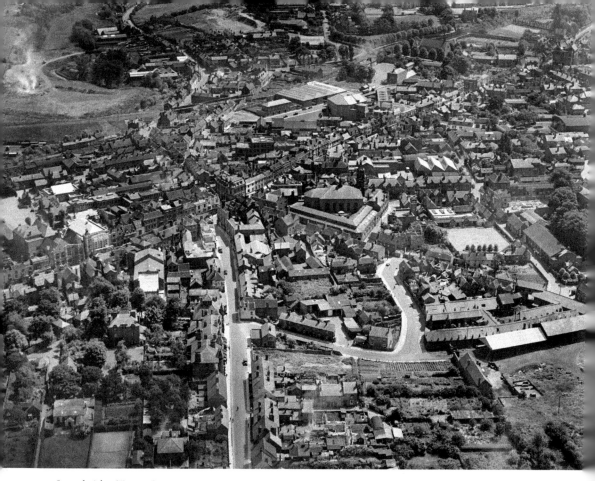

Stourbridge Town Centre

Stourbridge received its market charter fairly late in 1482. It was held in what is now Lower High Street, running from lower left to right. The large building near the centre of the picture is the Town Hall on Market Street, which opened in 1887 to commemorate Queen Victoria's Golden Jubilee and was designed by Thomas Robinson. In front of the Town Hall on Market Street and New Street is the old Market Hall, which was opened in 1827. The High Street continues on diagonally to the right. (© Historic England Archive. Aerofilms Collection)

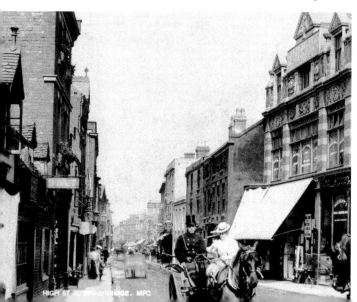

Stourbridge High Street

Pictured from the junction with Foster Street, the horse-drawn trap is just passing Bordeaux House to the right. Designed by Thomas Robinson and dated 1894, Bordeaux House was originally built for the wine merchant Edward Rutland. This rather fine building features decorative panels depicting grapes and vines in keeping with the name. Nowadays, it is more familiar as the office of a building society. (Historic England Archive)

Industrial Heritage

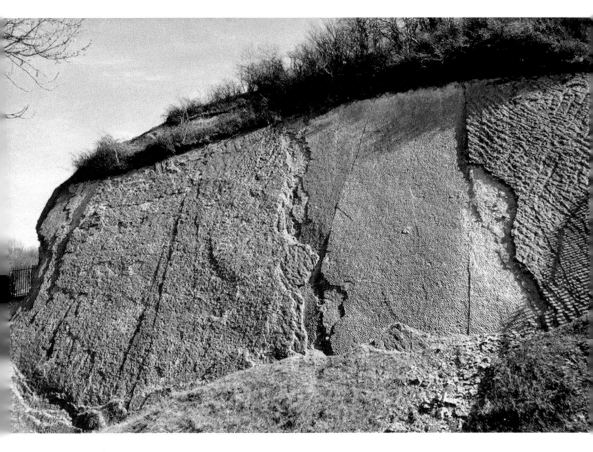

Mineral Resources

The Black Country grew up around its mineral resources: coal, iron ore, limestone, sand for castings and clay for bricks, including the fire clay used in the glass industry. Pictured are the world-famous limestone Ripple Beds at Wren's Nest near Dudley. Limestone was extensively mined here as it was the essential flux for iron making. Once a Silurian sea, the ripples were created when the tide went out over 400 million years ago. (Copyright Ashley Dace)

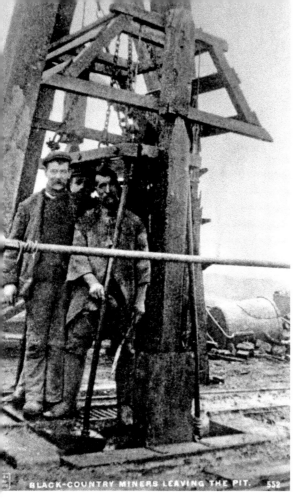

BLACK-COUNTRY MINERS LEAVING THE PIT. 552

Left and below: Mining for Coal
Most of the Black Country lies on the South
Staffordshire Coalfield. Varying thicknesses
of coal are found at different levels, but
the famous 30-foot seam is the thickest to
be found in Britain. Pictured is a typical,
fairly small pit, of which there were once
hundreds in the area. Prior to the 1842
Mines and Collieries Act, boys as young
as six could work as trappers operating
the ventilation doors. After 1842 boys had
to be at least ten. (Copyright A. Smith/
Archive Images)

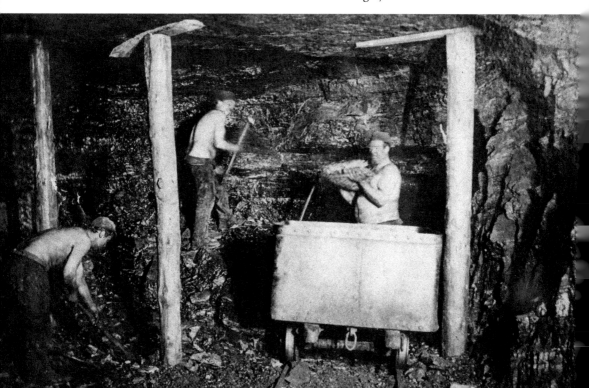

Pit Bonk Wenches

The 1842 Mines and Collieries Act made it illegal to employ any girls or women underground; however, female colliery workers could work above ground. Typically, they would be employed sorting and loading coal. Pictured are a group working at a pit in Wednesbury around 1900. In the Black Country dialect, they were known as the 'pit bonk wenches'. (Copyright Dudley Archives & Local History Service)

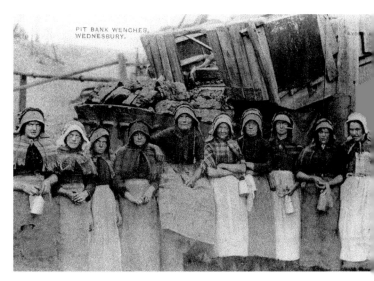

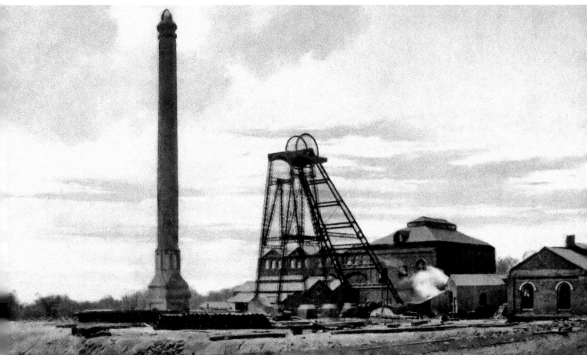

Baggeridge Colliery

When Baggeridge closed in 1968 it was effectively the end of coal mining in the Black Country. The postcard commemorates the opening of what was one of the most modern coal mines in the world when it reached full production in 1912. Mining was by the pillar and stall method, which left massive columns of coal to support the roof. Pit ponies were used to haul the coal tubs underground. The area has now been transformed into Baggeridge Country Park. (Copyright A. Smith/Archive Images)

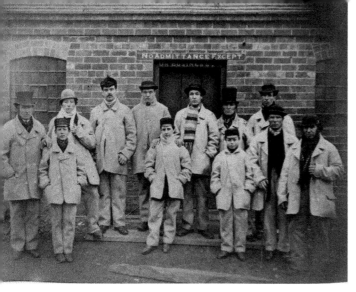

Nine Locks Colliery Disaster
In March 1869 a flood at the Earl of Dudley's Nine Locks Colliery at Brierley Hill trapped thirteen men and boys underground. Their ordeal lasted a week while frantic efforts were made to pump out the water using the mine's modern pump. The men and boys clung to each other for warmth and ate candles, pieces of leather and coal. A raft finally reached the miners, and all but one were miraculously brought out alive. (Historic England Archive)

Bilston Steelworks
In 1866, the Hickman family acquired the existing Springvale works. After continued expansion by 1920 it was in the hands of Stewarts and Lloyds. In 1954 three existing furnaces were replaced by just one, known affectionately as 'Elisabeth' after the daughter of the company chairman. Tradition had it that the new blast furnace must be lit by a young girl else it would go out! By the early 1970s Elisabeth was the last blast furnace in the Black Country. She was demolished in 1980. (© Historic England Archive. Aerofilms Collection)

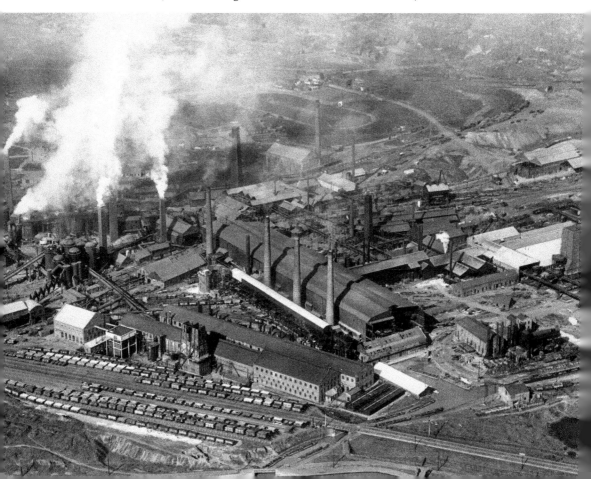

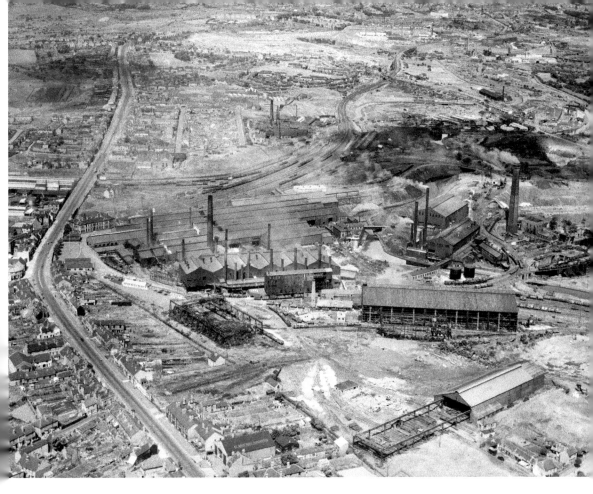

Round Oak Steelworks, Brierley Hill
The Round Oak Steelworks were owned by Lord Ward (later Earl of Dudley). It opened in 1857 and went on to employ thousands of workers. By 1894 Round Oak had moved into steel production. Known locally as 'the Earl's', Round Oak was finally nationalised in 1951, but was sold to Tube Investments in 1953. The year 1967 saw it nationalised again, before it was finally closed in 1982. The site was subsequently redeveloped by the Richardson brothers to become the Merry Hill Shopping Centre. (© Historic England Archive. Aerofilms Collection)

Russells Hall Blast Furnaces
A typical collection of blast furnaces photographed by a Mr Mills at Russells Hall, near Dudley, in 1859. During the Industrial Revolution it has been calculated that most of the iron made in the world originated from within approximately 20 miles of Round Oak at Brierley Hill, not far from Russells Hall. These blast furnaces would be typical of the smaller iron-making enterprises working to satisfy the almost insatiable demand for iron products. (Historic England Archive)

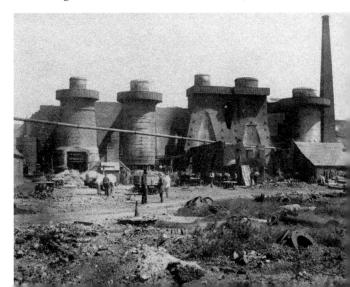

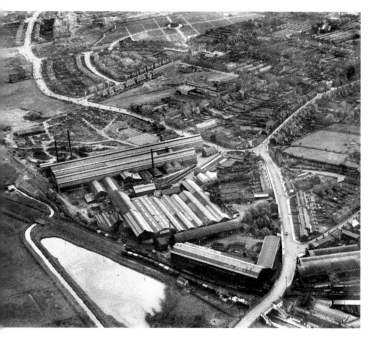

F. H. Lloyd & Co., James Bridge Steelworks

In 1879 Francis Henry Lloyd bought a disused timber yard at James Bridge on the outskirts of Darlaston, near Wednesbury, and set up a small foundry, which was to grow to become the biggest in Europe. The year 1937 was a record one for production, and during the Second World War the company produced steel castings for tanks and bombs, with an output of over 26,000 tons per year by the end of hostilities. The end came during the recession of the 1980s after over 100 years of production. (© Historic England Archive. Aerofilms Collection)

Beehive Kiln at Congreaves Brickworks, Cradley Heath
One of the readily available mineral resources in the Black Country was the clay used for brick making. Pictured is a typical beehive kiln used to 'burn' bricks, using wood or coke to start with and later on more controllable gas or oil. This was a major industry in the area, with bricks being needed not just for buildings but also furnaces and glass kilns requiring the special fireclay or refractory clay from around the Stourbridge area. (© Crown copyright. Historic England Archive)

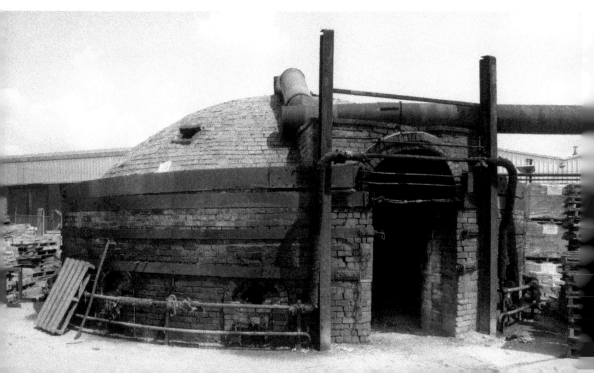

Stuart & Sons Glassworks, Stourbridge
Stuart & Sons were the manufacturers
of the famous Stuart crystal. When the
finest glassware was required for the ill-
fated RMS *Titanic*, it was Stuart & Sons
who supplied it. To the centre left of the
picture the Red House Glass Cone can
be seen, which was built in the 1700s but
was still producing Stuart crystal until
1936. On the opposite side of the road
is the White House Glassworks where
Stuart's transferred production in 1934.
Red House Glass Cone is now a museum.
(© Historic England Archive. Aerofilms
Collection)

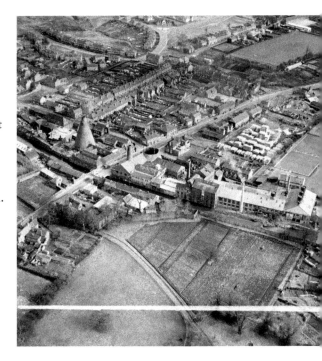

Dial Glassworks, Stourbridge
The metal-capped glass cone in the picture was built in 1788 at Dial Glassworks. The
brick top was removed in 1935 when it became unstable. To the left the opening to an old
service tunnel can be seen. Since 1922 it has been the home of industrial glassware makers
Plowden and Thompson. Dial Glassworks is also now home to Tudor Crystal, which still
employs traditional glassmaking skills to produce the products displayed in the factory shop.
(© Historic England Archive)

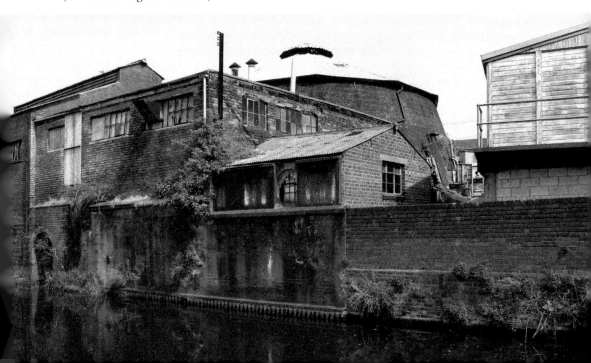

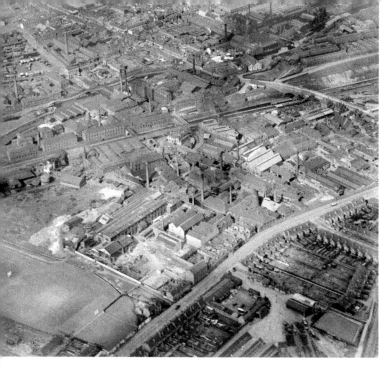

Left: Chance Brothers & Co.
The glass for the Crystal Palace, which housed the Great Exhibition of 1851, was supplied by Chance Brothers of Smethwick. At the same exhibition the company demonstrated a completely new design for lighthouse lenses. This was to prove so popular that they established a lighthouse works to satisfy the worldwide demand for these lenses. (© Historic England Archive. Aerofilms Collection)

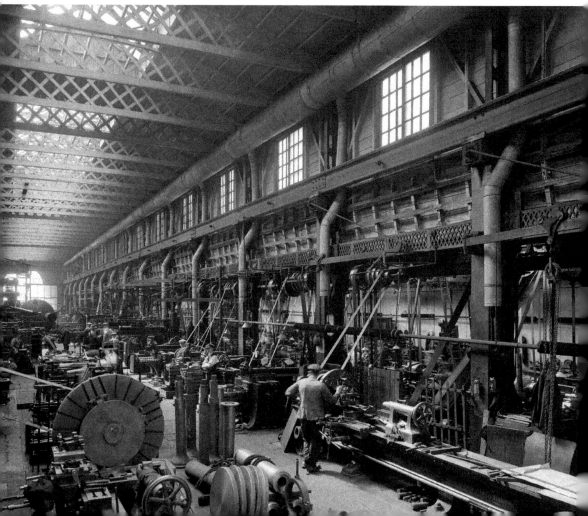

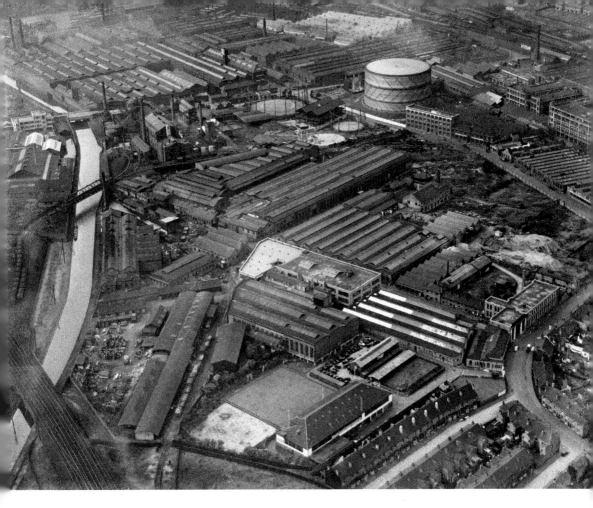

Above: Soho Foundry, Smethwick
By 1794 Matthew Boulton and James Watt were successfully supplying stationary steam engines to industry with parts mainly provided by suppliers. In conjunction with their sons they formed a new company and built the Soho Foundry, which opened in 1796. This was the first purpose-built steam engine works in the world. W. & T. Avery purchased the foundry in 1895 and the remaining buildings are pictured from the air in 1936. (© Historic England Archive. Aerofilms Collection)

Opposite below: Chance Brothers & Co. Workshop
Pictured here in 1920, this is one of the massive Chance Brothers & Co. glass workshops. Chance Brothers had been gradually bought out by rivals Pilkington, who gained full control by 1952. After over 150 years of production at the Smethwick site, Chance Brothers shut down in 1981. Several of the buildings are Grade II listed and the whole site is a Scheduled Monument. (Historic England Archive)

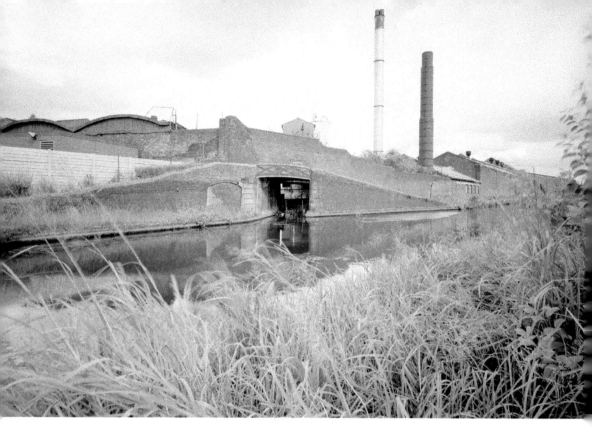

Above and below: Soho Foundry and Mint

The Soho Foundry, still owned by Avery, is a Historic England Scheduled Monument, including the foundry remains, associated buildings and the adjacent canal basin. Matthew Boulton had set up a mint at the Soho Manufactory in Handsworth, which was demolished in the 1850s. In 1860 James Watt & Co. decided to set up their own mint at the Soho Foundry to supply mainly foreign markets using Boulton-designed presses. The remains of this structure are also now safe from demolition. (© Crown copyright. Historic England Archive)

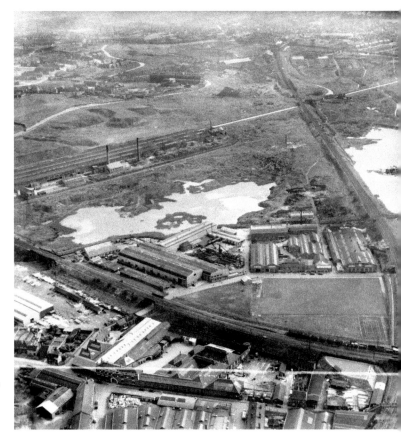

Right and below: Hill Top Foundry Anchor Works, Wednesbury Hill Top Foundry was established in 1799 to manufacture tubes. By the early 1930s business was so good that a much larger factory in Smith Road was purchased. By the time the aerial photograph was taken in 1949 the Anchor Works was producing specialist castings of all kinds, including aluminium. The company survives as Newby Industries, but the original Anchor Works frontage is preserved at the Black Country Living Museum. (© Historic England Archive. Aerofilms Collection; Author)

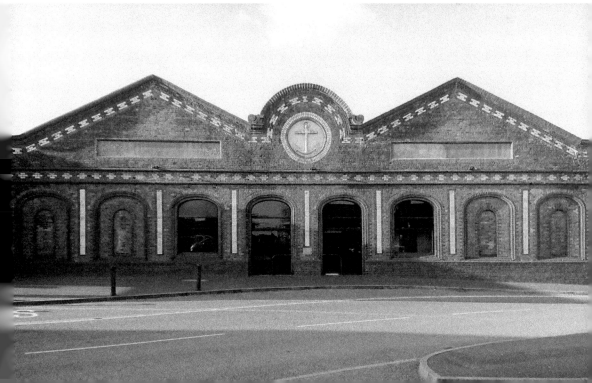

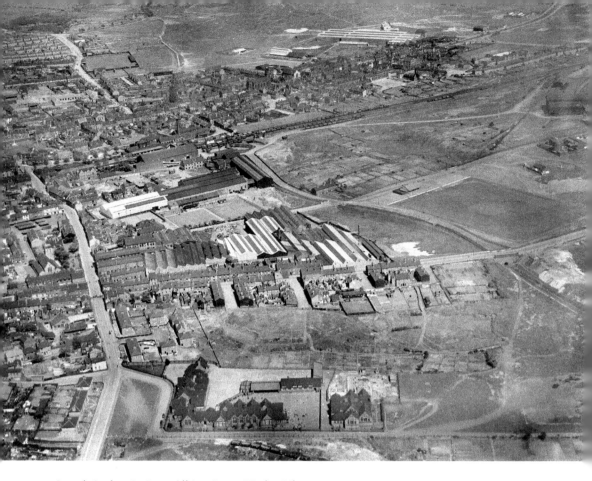

Joseph Sankey & Sons, Albion Street Works, Bilston
In 1854, Joseph Sankey was producing blanks for japanning, a process allied to enamelling that Bilston was famous for. By 1867 he had a factory in Albert Street producing holloware. They quickly diversified into the automotive industry, and in 1908 patented the first all-steel wheel for motor cars. Guest Keen Nettlefold acquired Sankeys in 1920, but it wasn't until the mid-1960s that the company became known as GKN Sankey. No longer in Bilston, part of the site is now a Morrisons supermarket. (© Historic England Archive. Aerofilms Collection)

John Thompson Boilers
In the late 1830s William Thompson began building boilers and canal boats. His son John acquired the company around 1860, and by 1870 he decided to concentrate on the production of steam boilers at a new site in Ettingshall, where the boilers pictured in 1928 were manufactured. The company flourished and by the 1920s included John Thompson Wolverhampton, John Thompson Dudley, John Thompson Motor Pressings and John Thompson Water Tube Boilers. The Ettingshall works closed in 2004. (Historic England Archive)

Leather Working in Walsall
The leather industry that Walsall is known for grew up on the back of an earlier trade, that of the loriner. Loriners made all the metal items needed for a horse's harness. Experienced leather worker Wendy Tipper is pictured practising traditional skills in an original Victorian workshop. The workshop is now part of Walsall Leather Museum, which tells the whole story of this ancient craft. (Author)

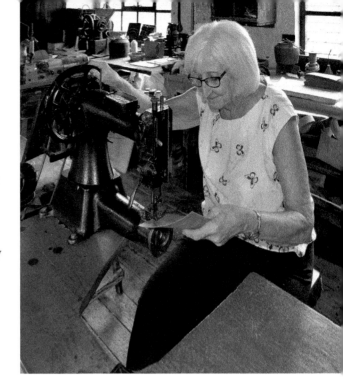

Domestic Nail Making
Around 1830 the handmade nail trade employed approximately 50,000 men, women and children, often living and working in appalling conditions. The dilapidated nail shop pictured around 1900 is attached to the rear of a typical worker's cottage. By this time domestic nail making was almost at an end due to the introduction of machine-made nails, particularly wire nails, from around 1875 onwards. (Copyright Dudley Archives & Local History Service)

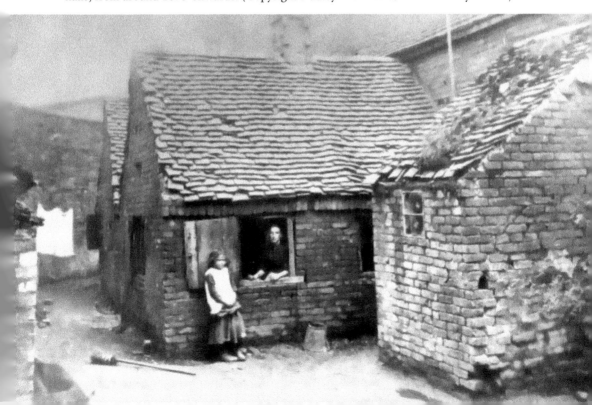

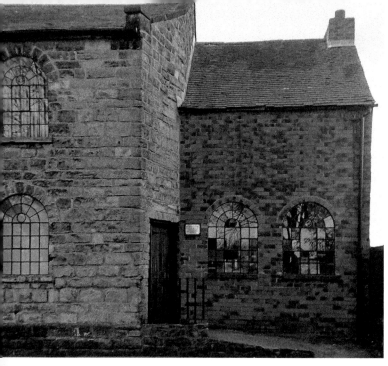

Sedgley Nail Shop and Warehouse
Along with Halesowen, Dudley, Lye, Old Hill and Gornal, Sedgley was a major centre for the handmade nail trade. Pictured is the Grade II listed nail warehouse and nail-making shop in Sedgley. Dating back to the peak of the handmade nail trade in the 1830s, it was built by Stephen Wilkes of local Ruiton stone. The red-brick porch was added later and was used as a nail shop until around 1900. (Author)

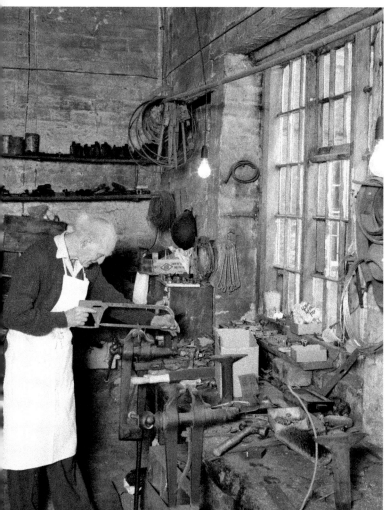

Lock Making, Willenhall
Willenhall, and to some extent nearby Wolverhampton, was central to the lock-making industry for centuries. Much of the industry took place in small backyard workshops, often with the whole family involved. Pictured in 1985 is the former home and workshop of the Hodson family, who lived and worked here from 1904 to 1983. The Locksmith's House, as it is known, is now preserved as a museum. (© Crown copyright. Historic England Archive)

Mushroom Green

Around the Cradley Heath, Netherton and Old Hill areas, thousands of men, women and children were involved in chain making, often in small workshops like Mushroom Green. The nineteenth-century chain shop is the very last one in situ where hand-hammered chain is still made. Nowadays it is preserved as a museum and is open for demonstrations in the afternoons on the second Sunday of every month between April and October. (Copyright Dave Marsh)

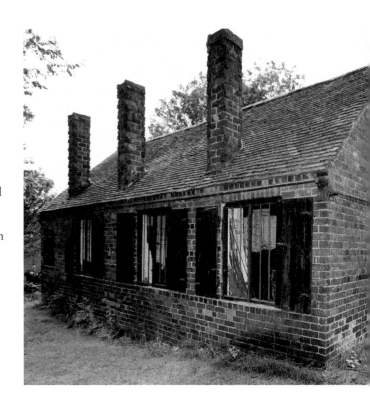

Cable Chain

The Black Country was renowned for the quality of its ships' chains and anchors. In the early 1800s, when chains started to replace hemp rope for anchors, it was found that open-link chains could tangle, causing the anchor to jam or even damage the ship. From 1813 a stay-pin or stud was added to the centre of each link. This served the dual purpose of helping to prevent tangling or kinking and also strengthened the chain. (Copyright Dave Marsh)

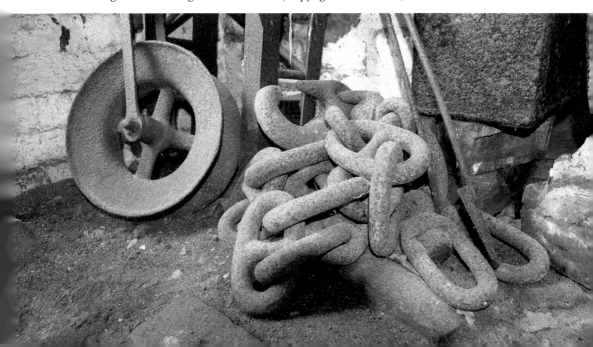

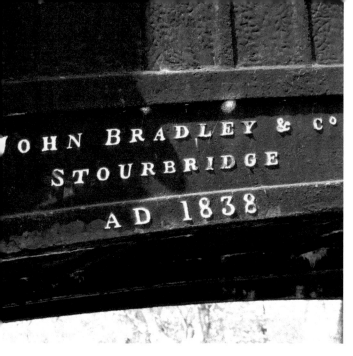

Left: John Bradley & Co., Stourbridge

This company was set up on the banks of the River Stour by John Bradley in 1800 to produce wrought iron. After John died in 1816, his half-brother James Foster was in charge. In 1819 he formed a partnership with John Rastrick, which would make railway history. The original company grew to be a significant manufacturer of iron products. It was finally sold off in 1919, although the name lived on as John Bradley (Stourbridge) Ltd until it was wound up in 1966. (© Historic England Archive)

Below and opposite above: Foster and Rastrick Foundry Building, Stourbridge

The partnership of Foster and Rastrick produced the first standard-gauge locomotive to run in the Midlands in 1829. This was the *Agenoria* for Lord Dudley's Shutt End railway, but she had three sister engines destined for America. One of these, the *Stourbridge Lion*, is famous for being the first railway locomotive to run on American rails. Engineer John Rastrick was one of the three judges at the Rainhill Trials in 1829. The preserved building is now home to a medical centre. (© Historic England Archive)

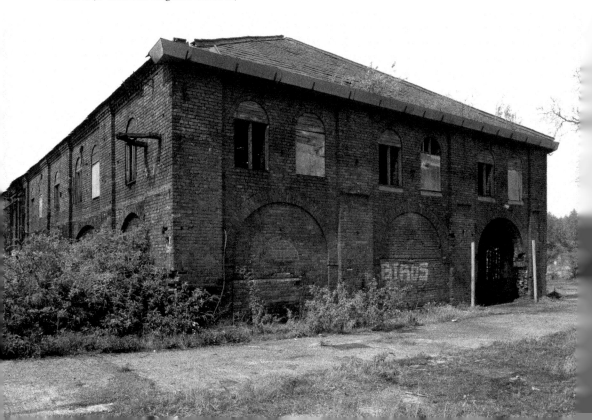

Below: National Projectile Factory, Hall Street, Dudley
By 1915 the 'shell scandal' highlighted the need to greatly increase capacity. The Ministry of Munitions, under Lloyd George, authorised the construction of National Projectile Factories such as the one in Dudley, which was completed in 1916. Of the 4,000 workers, many were women, who were known as munitionettes. Both men and women can be seen working on shells for 12, 14 and 18 pounder guns using machinery powered by overhead belts. (Historic England Archive)

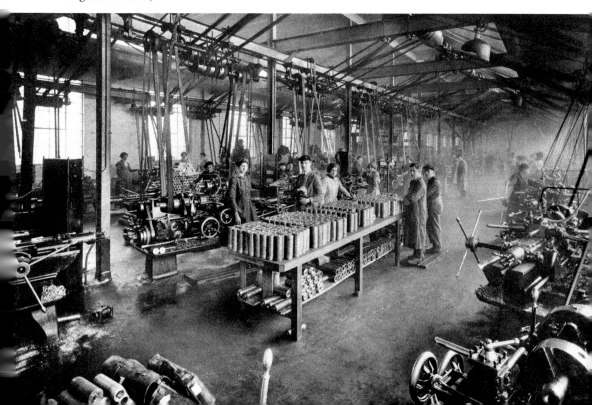

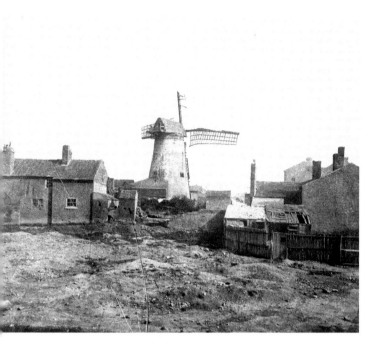

Left: Stafford Street Windmill, Wolverhampton
Even the industrialised Black Country had its windmills. This tower windmill was photographed around 1880. It was one of two windmills on Stafford Street, the other being a post windmill. Originally built on a farm, it had fallen into disuse and fell down around 1894 after being undermined for sand. Nothing remains of the windmill or the farm, but in the early 1900s the Windmill Steam Joinery Company was in existence on the site. (Historic England Archive)

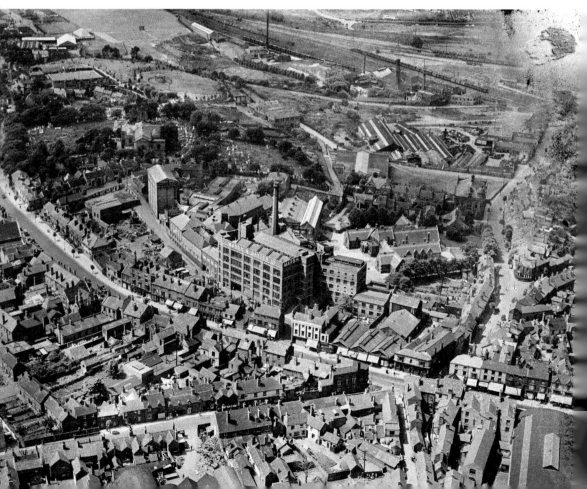

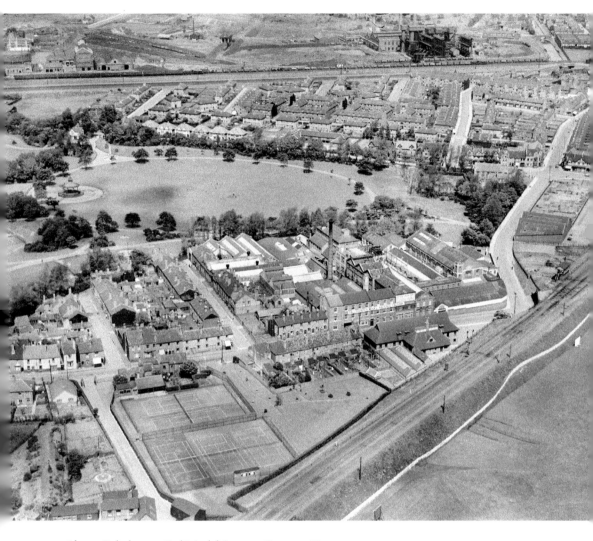

Above: Palethorpes Ltd Model Sausage Factory, Tipton
A very well-known name, particularly for sausages, was Palethorpes, pictured here in 1935. Henry Palethorpe was a Birmingham butcher who moved into meat processing. After moving his business to Tipton, by 1896 his model sausage factory was arguably the biggest in the world. In 1967 the company built a new facility in Market Drayton, which resulted in the closure of the Tipton factory in 1968. (© Historic England Archive. Aerofilms Collection)

Opposite below: Marsh and Baxter Ltd, Hall Street, Brierley Hill
Once a familiar name, at its peak Marsh and Baxters had fifty-two shops and the massive bacon factory in the centre of the picture, which was taken in 1931. In 1871 Alfred Marsh had a butcher's shop in Brierley Hill and was curing his own pork products in a small factory in Hall Street. It became Marsh and Baxter when Alfred Marsh took over A. R. Baxter's meat-processing factory in Dale End, Birmingham. The Hall Street factory closed in 1978 and all the shops were sold. (© Historic England Archive. Aerofilms Collection)

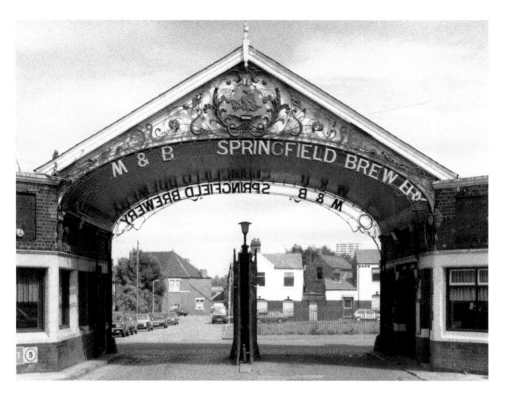

Springfield Brewery, Wolverhampton

The site was purchased in 1873 to house William Butler's expanding brewery business. Trading as William Butler & Co., production of beer at the new Springfield Brewery began in 1874. After William Butler's death in 1893 the family name carried on through his sons. The family connection ended in 1950. In 1960 the company was bought by M&B and production began to decline. Brewing ended in 1990 and Springfield Brewery closed in 1991. (© Crown copyright. Historic England Archive)

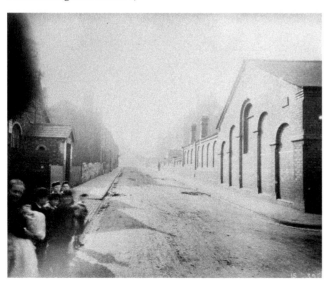

Springfield Brewery from Grimstone Street

Initially producing around 400 barrels of beer per week, by the time this picture was taken in 1883 the Springfield Brewery was producing up to 1,500 barrels per week. Much of the site was destroyed in a major blaze in 2004. The University of Wolverhampton purchased the site in 2014 and are restoring as much of the old brewery as possible, including the main gates and the 1922 clock tower, to form a new Springfield Campus. (Historic England Archive)

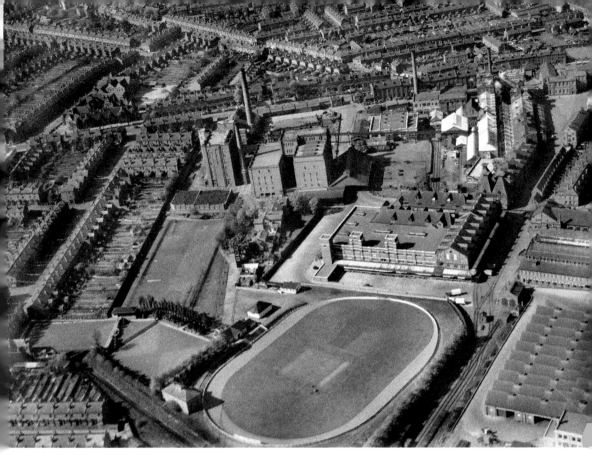

Cape Hill Brewery, Smethwick

Brewer Henry Mitchell moved into a new brewery at Cape Hill in 1879. In 1898 a merger took place with William Butler to create Mitchell and Butler's Ltd. M&B was born. All production from the merged breweries took place at the large Cape Hill Brewery. In 1961, M&B merged with Bass to eventually become Bass plc. The brewery closed in 2002 and was demolished in 2005, with only the M&B war memorial being preserved. (© Historic England Archive. Aerofilms Collection)

Langley Maltings, Oldbury

Pictured here in 1956, Langley Maltings were built to provide malt to the nearby Showell's Crosswell Brewery, which opened in 1870. They were rebuilt in 1898 after a major fire. Wolverhampton and Dudley Breweries, now renamed Marston's plc, purchased the maltings from Showells in 1944. Malting ended on the site in 2006 and the derelict building was partially destroyed by fire in 2009. The Victorian Society listed Langley Maltings on their list of the top ten buildings to save in 2018. (Historic England Archive)

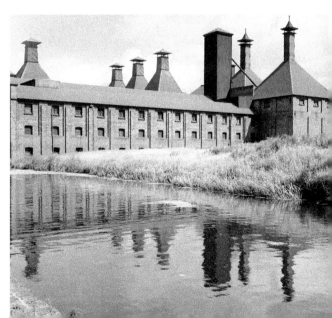

House and Home

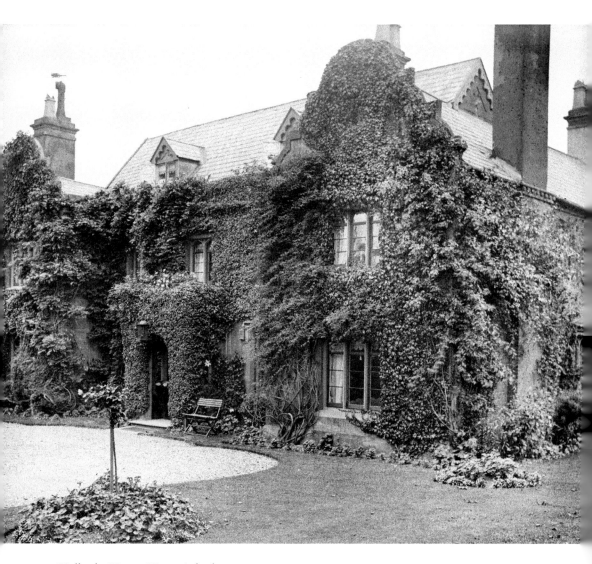

Holbeche House, Kingswinford
A quiet country house when pictured in 1912, it was a different story in 1605 when the remaining gunpowder plotters made their last stand here against the Worcestershire militia. They had raided Warwick Castle for fresh horses and replenished stocks of gunpowder from Hewell Grange. In trying to dry the damp powder it exploded and alerted the Sheriff of Worcestershire. The remaining plotters were either killed or captured apart from Robert Wintour and Stephen Lyttleton, who escaped. (Historic England Archive)

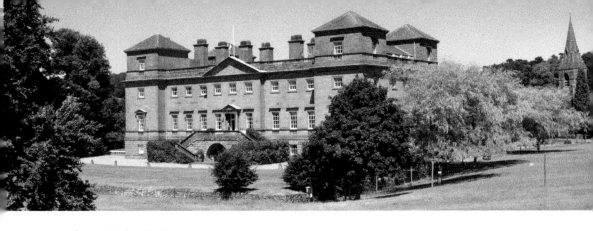

Above: Hagley Hall

The eighteenth-century Palladian mansion replaced an earlier wooden house at Hagley Park. It was here that Robert Wintour and Stephen Lyttleton eventually sought assistance from Humphrey Lyttleton. Despite being sworn to secrecy the cook, John Fynwood, betrayed the pair. When the authorities arrived another servant, David Bate, pointed them to the courtyard where the plotters were attempting to escape, and they were finally captured. (© Historic England Archive)

Below: Moseley Old Hall, Wolverhampton

Following his defeat at the Battle of Worcester in 1651, Charles II escaped firstly to White Ladies Priory, reportedly taking refreshment at Wordsley on the way. After an aborted attempt to cross the River Severn, Charles was taken to Boscobel House where he famously hid in the oak tree. From there the Pendrell brothers took him to Moseley Old Hall, just outside Wolverhampton, which was owned by Thomas Whitgrave. He was forced to hide here from Parliamentarian soldiers in a priest hole. (Author)

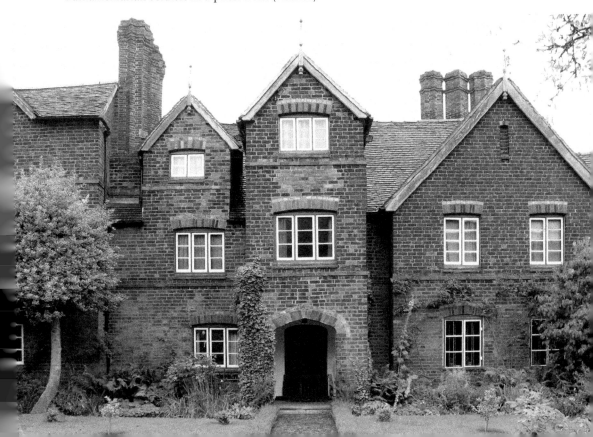

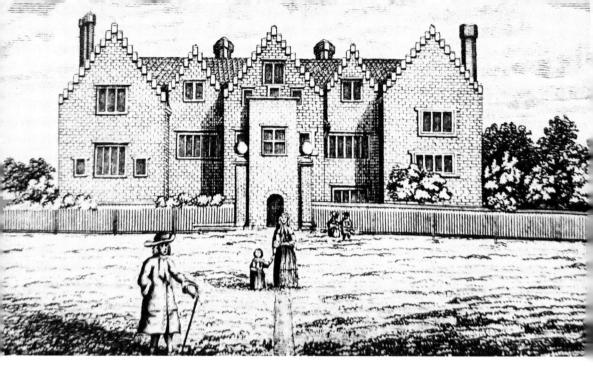

Above: Bentley Hall, Walsall

From Moseley Old Hall Charles travelled to Bentley Hall. This was the home of Royalist Colonel John Lane, brother to Jane Lane. Jane had a pass to visit a pregnant friend at Abbot's Leigh in Somerset, not far from Bristol. While at Bentley Hall a plan was conceived to disguise Charles as Jane's manservant. He was given the name William Jackson and accompanied her to Bristol, where Charles was eventually able to get safe passage to France. (Permission of Sandwell Community History & Archives Service)

Below: Himley Hall, Dudley

Originally a moated manor house, the 6th Baron Ward inherited it in 1740 and had the Palladian-style mansion built. His son later employed Lancelot 'Capability' Brown to landscape the park. In 1920, having sold Witley Court in Worcestershire, where the family had moved to in the mid-1800s, William Humble Eric Ward turned Himley into a luxury retreat. No expense was spared on lavish rooms, an indoor swimming pool and even a private cinema. Royalty were frequent visitors here, including Edward and Mrs Simpson. (Author)

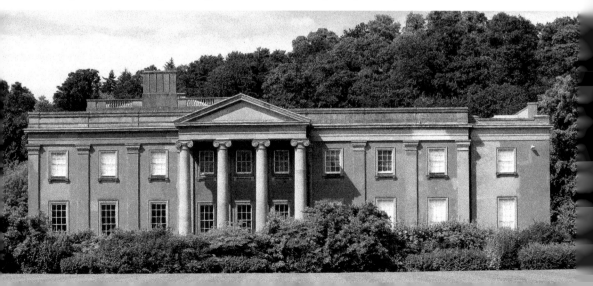

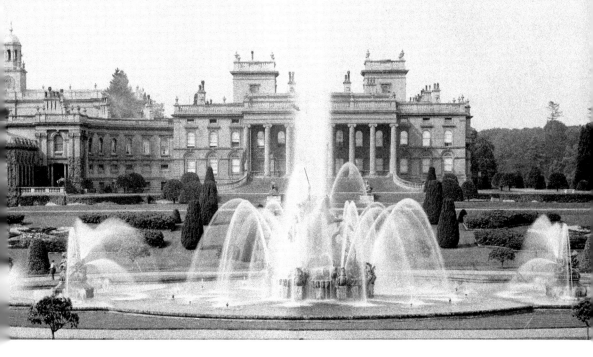

Perseus and Andromeda Fountain, Witley Court

While not in the Black Country, Witley Court is closely associated with the earls of Dudley, who made their considerable fortune from the vast mineral resources obtained through favourable enclosure acts and the industrialisation that followed. In the 1830s, with the smoke and grime of the Black Country encroaching ever closer, the young William Ward persuaded his trustees to buy this magnificent stately home in Worcestershire, although Himley Hall was kept on as a dower house. (Historic England Archive)

Sandwell Hall Arch Lodge, West Bromwich

Arch Lodge is virtually all that remains of Sandwell Hall, once home to the Legge family, the earls of Dartmouth. By 1848, Sandwell Hall was being seriously affected by smoke from local industry and, as with the Ward family at Himley Hall, they moved out, in this case to a large estate in Patsull. Sandwell Hall itself was finally demolished in 1928, leaving just the Grade II listed gateway entrance, Arch Lodge, now situated on the nearby motorway island. (Copyright Richard Law)

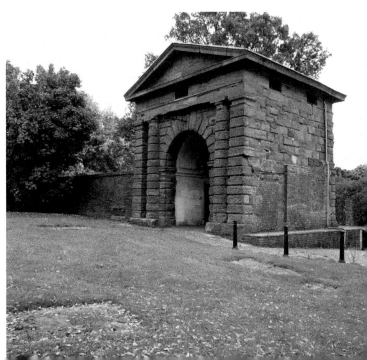

Sandwell Park Farm, Sandwell Valley, West Bromwich
Sandwell Valley largely escaped the ravages of the Black Country, surviving since medieval times when it was home to Sandwell Priory and, much later, Sandwell Hall. Sandwell Park Farm dates back to around 1800 and the buildings are Grade II listed. It was originally built to be the home farm on the Earl of Dartmouth's estate. It is now a restored working farm and open to the public. (© Crown copyright. Historic England Archive)

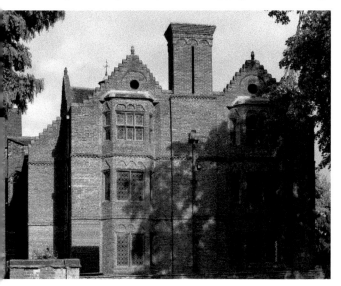

Haden Hill Old Hall, Cradley Heath
Originally built around 1600, Haden Hill Old Hall is the earlier of two fine houses in Haden Hill Park. Next to it is Haden Hill House, a Victorian gentleman's residence built in 1878 and now a museum. Ann Eliza Haden was the last family member to live in the old hall, passing away in 1876. As an old lady she became a recluse but managed to preserve her beloved 55 acres of parkland in the face of the Industrial Revolution raging all around her. (Author)

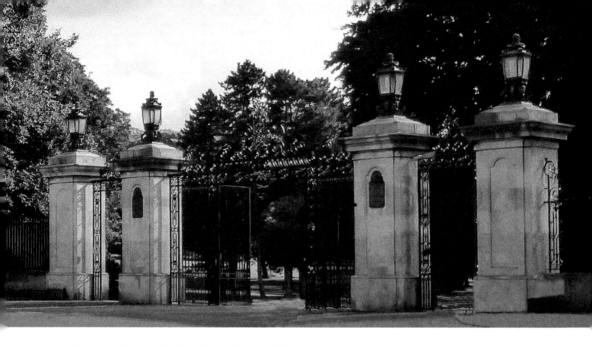

Above and below: Studley Court, Stourbridge

Pictured in 1897, this was once the home of Edward Webb, a wealthy seed merchant, who had renamed it Studley Court. By 1923 it had become St Andrew's Convent School. In 1929, Ernest Stevens, who made his fortune in Judge kitchenware, purchased the house and extensive grounds from the nuns. Ernest lost his wife, Mary, in 1925 and made several sizeable public donations to preserve her memory. One of these was Mary Stevens Park, which opened in 1931. He also purchased the impressive main gates. (Historic England Archive; Author)

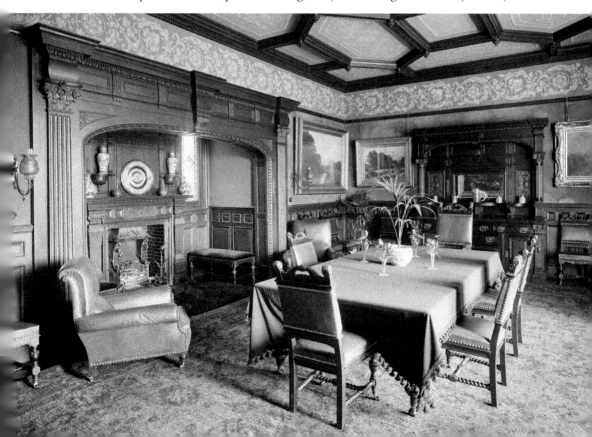

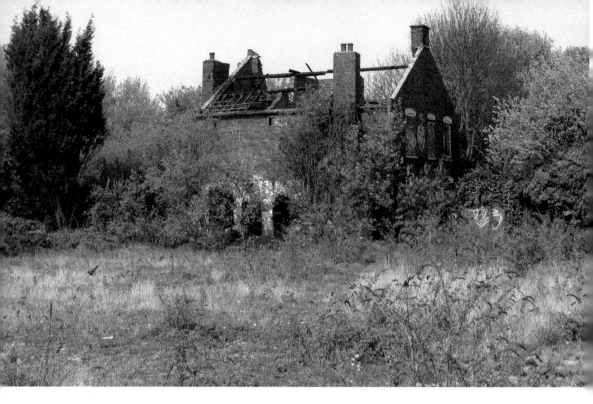

Riverside House, Stourbridge
Once an elegant nineteenth-century house, Riverside was the residence of the manager of the John Bradley & Co. Ironworks on the same site. The house had a walled garden, which faced the canal. Not quite visible in the picture are the false windows that would have been painted to match the genuine windows. This was to avoid payment of the window tax! Although a ruin, the Grade II listed house is now part of a restoration project. (© Historic England Archive)

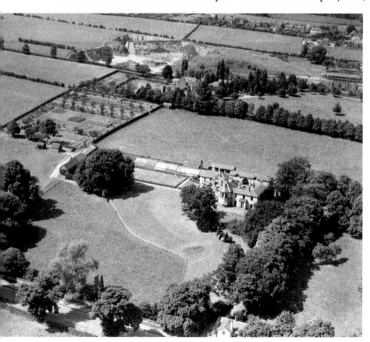

Woodfield House, Kingswinford
Woodfield House was home to ironmaster Henry Sparrow. In 1862, he took out a six-year lease on Corbyn's Hall Ironworks, near Pensnett. Shortly after taking over a terrible boiler explosion occurred on 28 February, which killed six men and injured several others. A 13-ton boiler heated by adjacent furnaces and powering a steam hammer had exploded. Engineer Mark Simpson was accused of negligence in letting the boiler run dry and charged with manslaughter. (© Historic England Archive. Aerofilms Collection)

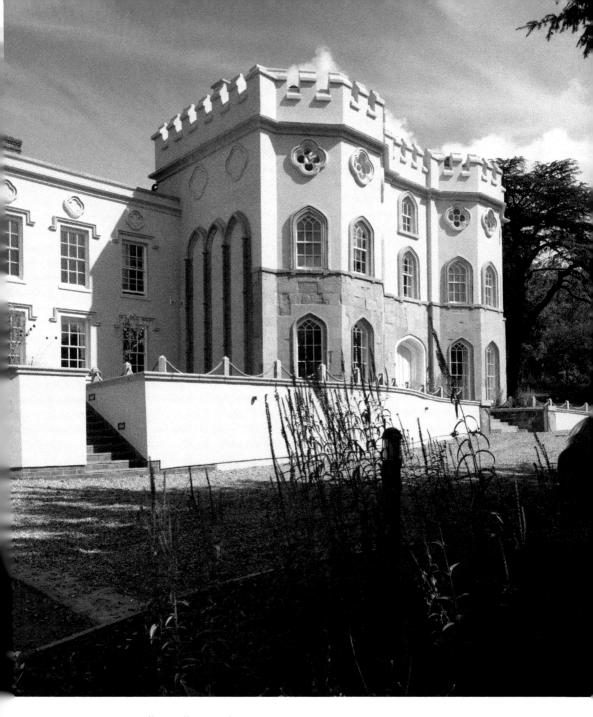

Corngreaves Hall, Cradley Heath

Built around 1795, Corngreaves Hall was home to influential ironmaster James Attwood. The striking castle-like frontage was added in the early nineteenth century. He built the first ironworks at Corngreaves around 1810, which was greatly enlarged by his son John. In 1843, the company became known as the New British Iron Company, a major local employer. After the company was liquidated in the 1890s the hall passed to one of the creditors, and eventually to Rowley Regis Borough Council. (© Historic England Archive)

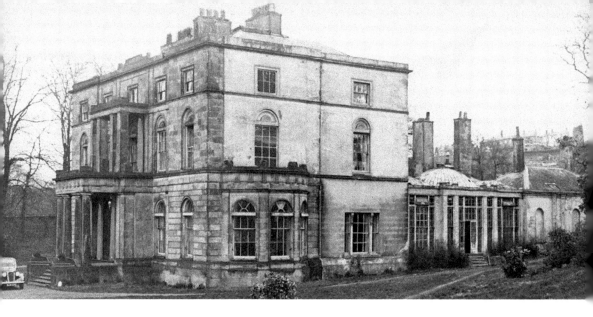

Above: Ellowes Hall, Lower Gornal

Ellowes Hall, known locally as 'the Ellowes', was designed by Thomas Lee Jr and built of local Gornal stone for wealthy ironmaster John Turton Fereday. In 1820 he had exchanged land with Viscount Dudley and Ward to build the mansion. The estate was sold to William Baldwin in 1850. A succession of wealthy owners followed. Unfortunately, Ellowes Hall mirrored the decline of the industry around it and was demolished to make way for a school in 1964. (Courtesy of the *Express & Star*)

Below: Tettenhall Towers, Wolverhampton

Tettenhall Towers was home to the eccentric philanthropist and inventor Colonel Thomas Thorneycroft. His father, George Thorneycroft, had ironworks in Walsall Street and was the first Mayor of Wolverhampton. Thomas purchased the house in 1853 and set about extending it, adding the towers in 1866. He constructed a theatre complete with water cascade fed from a tank in one of the towers, together with heating and ventilation systems of his own design. He was known for communicating with his workforce in semaphore from the top of one of the towers. (Author)

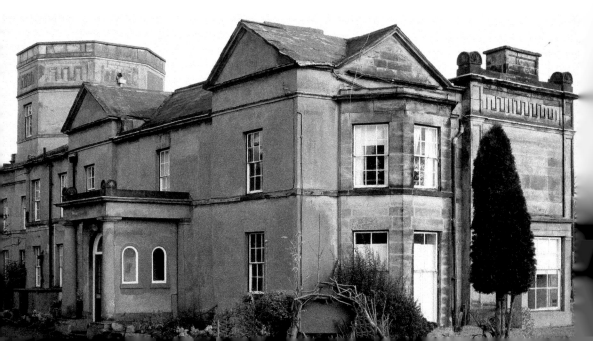

Right: Workers' Houses from Brook Street, Woodsetton

Once common, these small houses were cheap for poorer working families to rent. Built around 1852, the one on the left is two small houses built 'back to back' – the rear house faces the yard. Both houses have a kitchen and small pantry with one bedroom upstairs. The house on the right is a bigger 'two up two down' with two downstairs rooms and two bedrooms. Preserved at the Black Country Living Museum, they are believed to be the last of their type in the Black Country. (Author)

Below: Workers' Cottages

These typical 1820s workers' cottages were originally built with just one room and a pantry downstairs and one bedroom upstairs. They were later extended to add a parlour and a second bedroom, making them 'two up two down'. The overcrowding could be dreadful in small cottages such as these, with children sharing a bed and sleeping head to toe or 'top to tail'. They are displayed as they would have been around 1910 at the Black Country Living Museum. (Author)

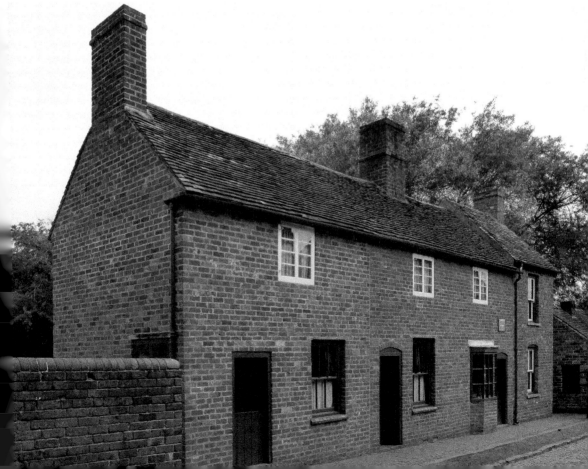

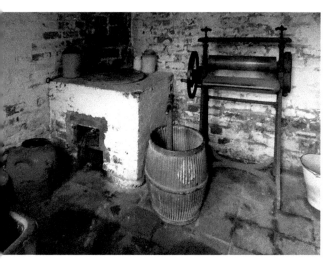

Brewhouse or 'Brewus'
Workers' cottages had an outbuilding known as the 'brewhouse', or 'brewus' in the local dialect. This would be used for washing clothes on wash day. The coal-fired copper was the only means of heating large amounts of water, but it wasn't just used for boiling whites on a Monday. Many Black Country working families also brewed their own beer in the copper. It was regarded as a healthy drink, and compared with much of the contaminated water supply at the time it probably was. (Author)

Showell Circus, Low Hill, Wolverhampton
The 1919 Addison Act instilled local authorities with a responsibility to provide decent housing for working people. Government subsidies led to the construction of big interwar council estates. The Wheatley Act of 1924 increased these subsidies. In 1924, Wolverhampton Borough Council purchased land around Low Hill and set about building one of the largest council estates in the country. The estate was loosely planned on garden city principles; the geometric design of circuses and curved streets can clearly be seen from the air in this 1939 image. (© Historic England Archive. Aerofilms Collection)

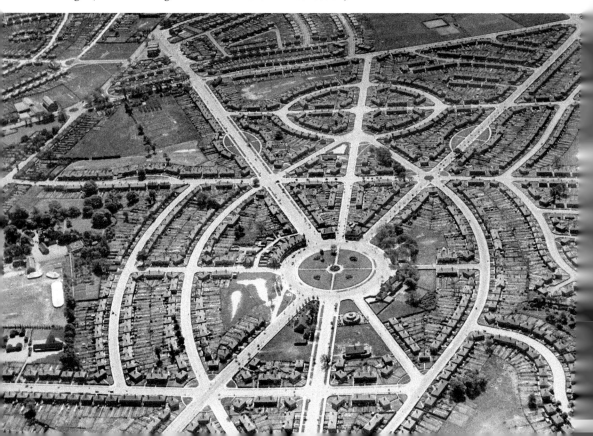

Religion and Education

Right and below: St Mary's Abbey, Halesowen

Halesowen Abbey was founded in 1215 after King John gave the manor of Hales to Peter des Roches, Bishop of Worcester, to build a religious house. The abbey was occupied for over 300 years by Premonstratensian Canons, known as White Canons due to their undyed habits. The abbey was dissolved in 1538 and partly demolished. Parts of the abbey were incorporated into the North Barn of Manor Farm. Pictured here in 1913 are the remains of the refectory and the only surviving building, which was most likely an infirmary. (Historic England Archive)

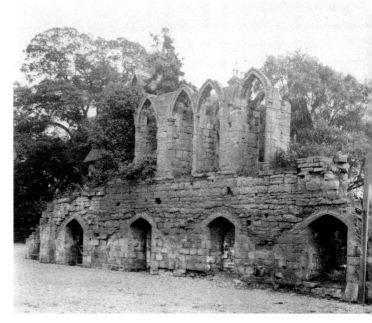

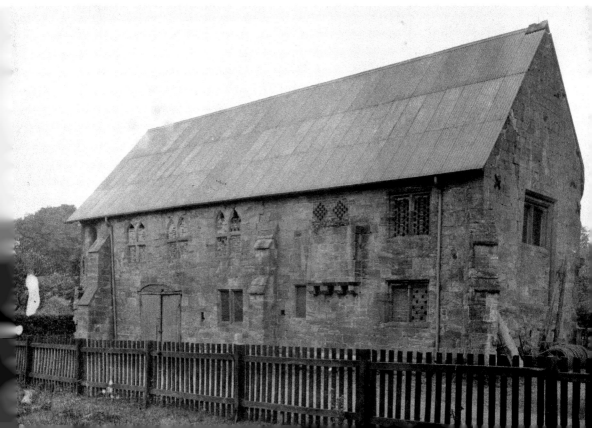

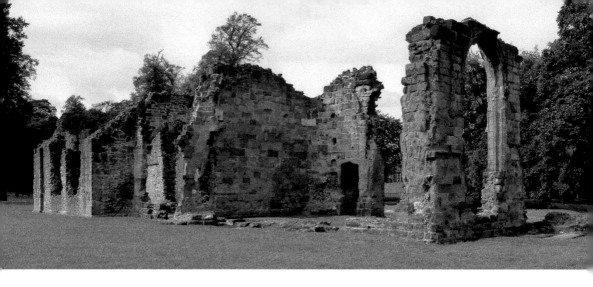

Dudley Priory
Dudley Priory of Cluniac monks was founded around 1150 by Gervaise de Paganel and dedicated to St James. This was a religious house dependent on both the nearby Dudley Castle and the Cluniac mother house of Much Wenlock. It served as a place of burial for the lords of Dudley and served as a guesthouse for the castle. Dissolution came in 1539 when the priory was granted to John Dudley, Duke of Northumberland. It remains a Grade II listed ruin in Priory Park. (Author)

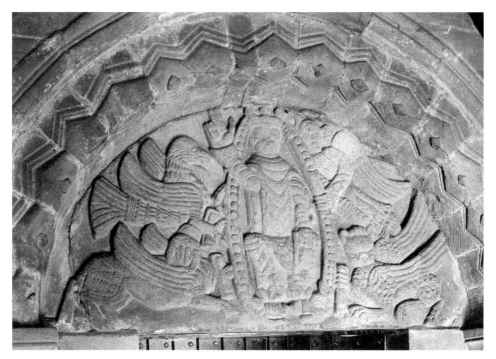

St Peter's Church Tympanum, Pedmore, Stourbridge
St Peter's was built in 1871, replacing a late eleventh- or twelfth-century church. Little remains of the earlier church, but above the south door is a Romanesque tympanum. The Lord is seated with his right hand in benediction and framed by two serpents. The symbols of the evangelists are carved on either side. On the left is the eagle of St John above the bull of St Luke, and on the right is the winged man of St Matthew above the lion of St Mark. (Historic England Archive)

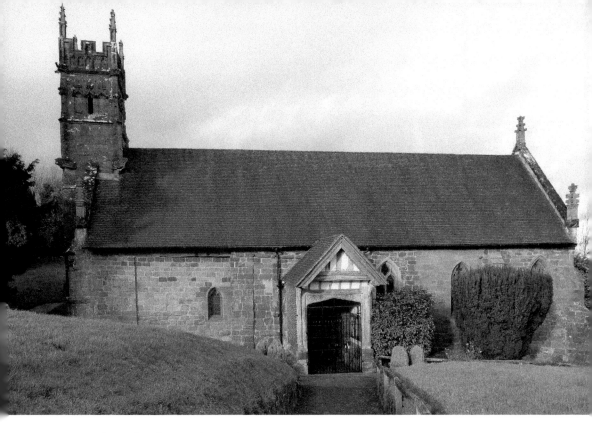

St Kenelm's Church, Romsley, Halesowen
Bubonic plague, the Black Death, reached the Black Country in the summer of 1349, but little is recorded with the exception of the Halesowen area where over 40 per cent of the local population perished. The 'lost' medieval village of Kenelmstowe had built up around the little St Kenelm's Church from at least 1280 in the reign of Edward I. While the village is known to have survived the Black Death, the losses may well have influenced its later demise and disappearance. (Author)

Our Lady and St Thomas of Canterbury Roman Catholic Church, Dudley
This was one of the earliest churches designed by celebrated architect Augustus Pugin. It was built of local stone over the period 1839 to 1840 in the style of a traditional Early English church, complete with rood screen, which was later removed. Pictured in 1858, Dudley Castle can be seen in the background. It cost a not unreasonable £3,165 to complete. In the 1960s the church was modernised and unfortunately lost some of its original features. (Historic England Archive)

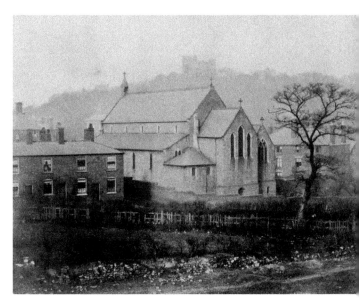

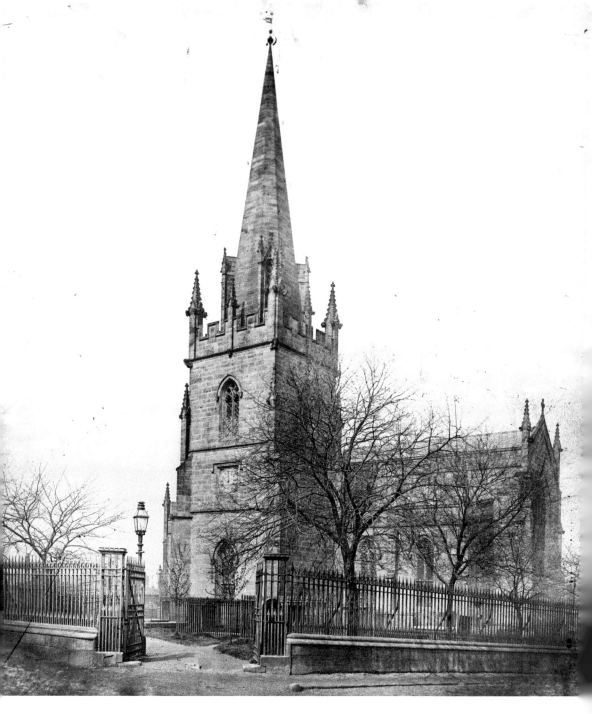

All Saints' Church, Sedgley
Already a religious site in the Domesday Book of 1086, the present church, pictured in the 1870s, was rebuilt between 1826 and 1829, replacing a smaller church. It was paid for by Viscount Dudley and designed by Thomas Lee, incorporating some of the earlier medieval tower within the new one. Joseph Gillott of Birmingham is usually associated with developing steel pen nibs, but Thomas Sheldon may have predated him by producing them in Sedgley around 1800. He is buried in the churchyard. (Historic England Archive)

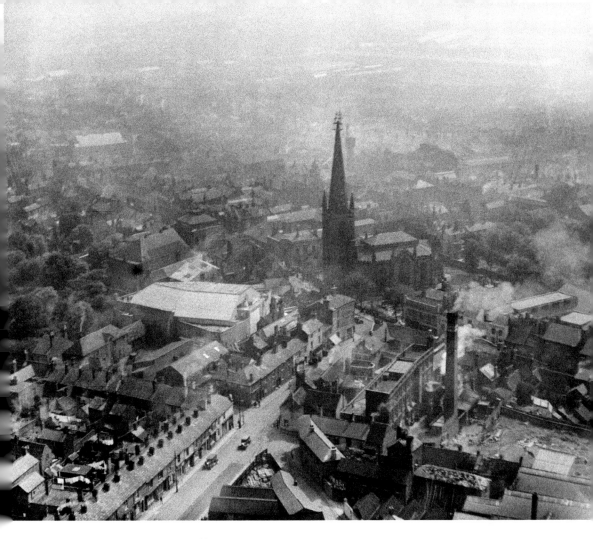

Church of St Thomas, Dudley

Situated at the top end of the High Street, St Thomas's is known locally as 'Top Church'. St Edmund's at the other end is known as 'Bottom Church'. It was designed in Perpendicular style by William Brooks and built between 1815 and 1818. Replacing an earlier medieval chapel, remains of this can still be seen in the crypt. The building towards the bottom right of the aerial picture is the Julia Hanson & Sons brewery, later bought out by Wolverhampton and Dudley Breweries in 1943. (© Historic England Archive. Aerofilms Collection)

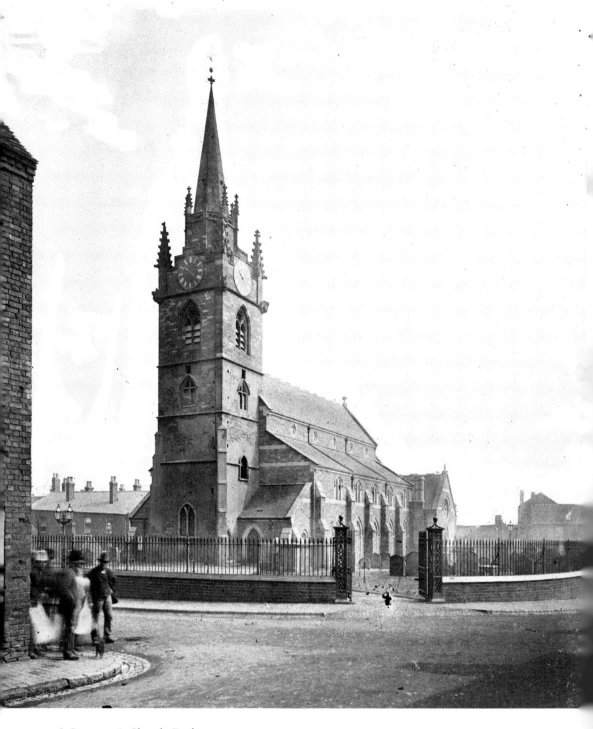

St Lawrence's Church, Darlaston
After the Norman Conquest William de Darlaston founded the first church at Darlaston. Since
then it has been rebuilt a number of times. The wooden tower was so dangerous in the early
seventeenth century that famous Darlaston clergyman Dr Pye paid for a new stone one. Later
in the same century the church burnt down and was rebuilt. In 1807, the church was rebuilt in
brick. The main church in stone dates to 1872, designed by A. P. Brevitt. In 1907, the spire was
rebuilt and a new clock was added. (Historic England Archive)

Right: St Lawrence's Mother and Child Statue
In the churchyard there is a large statue of a mother
and child by sculptor Thomas Wright. The statue was
commissioned by Darlaston Urban District Council
and unveiled in 1958. It was erected to commemorate
Harry Bishop Marston, a local businessman and
long-serving council member. The statue is subject to
an unusual local legend: the child is said to come to
life and walk around the churchyard, separate from
the mother, who remains a figure in stone. (Author)

Below: St Peter's Collegiate Church, Wolverhampton
The church was founded by Lady Wulfruna in AD 994
and dedicated to St Mary. It became St Peter's in
the twelfth century. The oldest part of the building
dates to around 1200, while much of the church
was enlarged and rebuilt in both the fourteenth and
fifteenth centuries, with the later additions funded by
wealthy wool merchants. The chancel was damaged
during the English Civil War and rebuilt in 1682.
The nineteenth century saw a major restoration by
architect Ewan Christian, including restoring the
chancel to its former glory. (Historic England Archive)

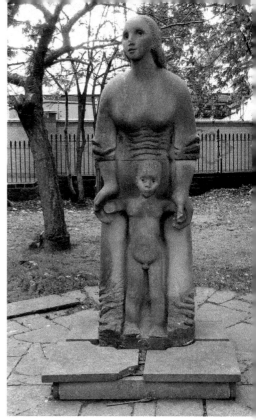

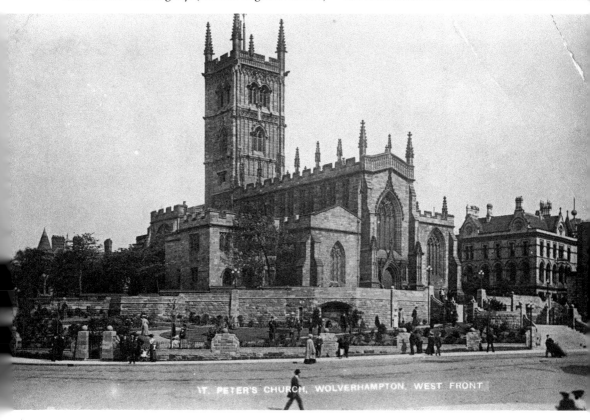

ST. PETER'S CHURCH, WOLVERHAMPTON. WEST FRONT

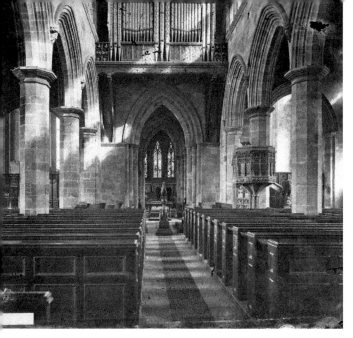

The Nave of St Peter's
St Peter's is a Grade I listed building, and is pictured looking east along the nave in 1870. The mid-fifteenth-century panelled stone pulpit can be seen to the right. A crouching lion sits at the base of the stone steps, presumably there to guard the clergy. From 1480 to 1846 the church was a royal peculiar and associated with St George's Chapel, Windsor Castle. This was a church belonging directly to the monarch and not under the jurisdiction of a bishop. (Historic England Archive)

St Peter's Misericords
One of the many interesting features of this church are the carvings on the arms of the stalls and the misericords beneath the seats. 'Misericord' comes from the Latin for mercy, *misericordia*. Misericords are sometimes called 'mercy seats'. In the monastic tradition medieval clergy were not supposed to sit down during often very long services. The misericords were carved ledges where they could discreetly rest their derrieres! Often, they were carved with humorous designs, medieval folklore and even pagan references such as the green man. (© Historic England Archive)

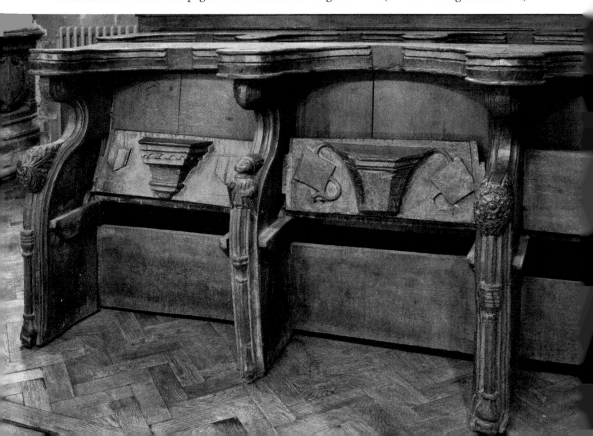

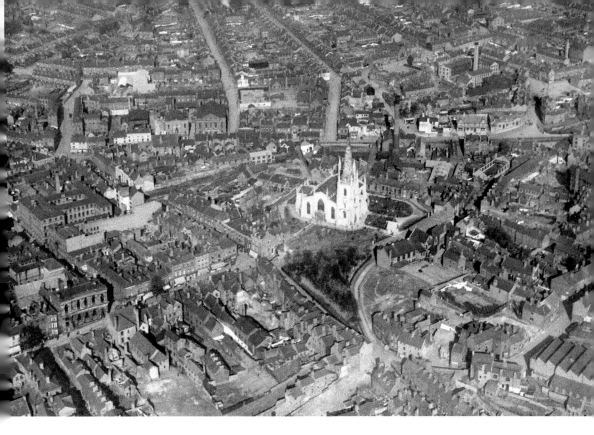

St Matthew's Church, Walsall
Pictured from the air in 1926, St Matthew's Church looks out over the busy town of Walsall, as it has done for hundreds of years. The chancel was rebuilt in the fifteenth century and restored by Ewan Christian in 1879–80. The nave was restored in 1819–21 by Francis Goodwin, who also clad the exterior and the tower in Bath stone. The inner crypt is reputed to be the oldest surviving man-made construction in Walsall and dates back to the thirteenth century or possibly earlier. (© Historic England Archive. Aerofilms Collection)

Walsall Memorial Garden
The area to the south of St Matthew's Church, seen in the background, had become very built up by the eighteenth century. By the nineteenth century it was very rundown, and in the 1930s slum clearance rehoused the remaining residents in new council houses. After the Second World War, in 1947, Geoffrey Jellicoe was given a contract to develop the land as a memorial garden to the Walsall dead of both world wars. The beautiful and tranquil Church Hill Memorial Garden formally opened in 1952. (© Historic England Archive)

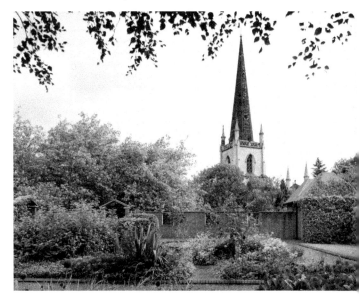

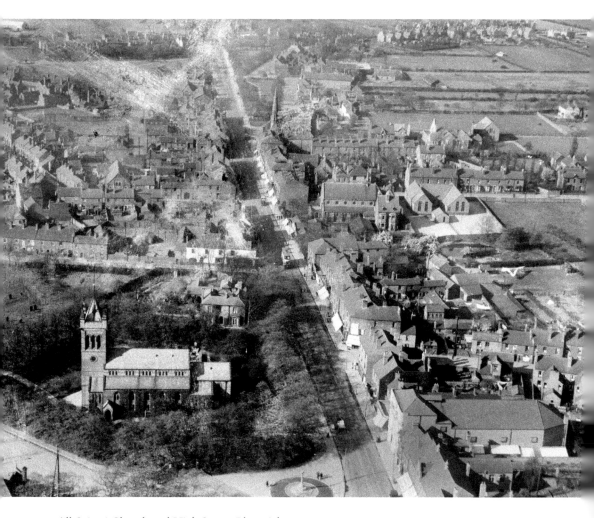

All Saints' Church and High Street, Bloxwich

In the centre of this picture, taken in 1926, a tram can just be seen passing the former George public house to the left on the High Street. All Saints' Church, bottom left, was built around 1794. Originally dedicated to St Thomas of Canterbury, it was rededicated in 1875 following extensive alterations. The oldest monument in Bloxwich can just be seen front and centre of the church. This is an ancient medieval preaching cross, which suggests much earlier religious use of the site. (© Historic England Archive. Aerofilms Collection)

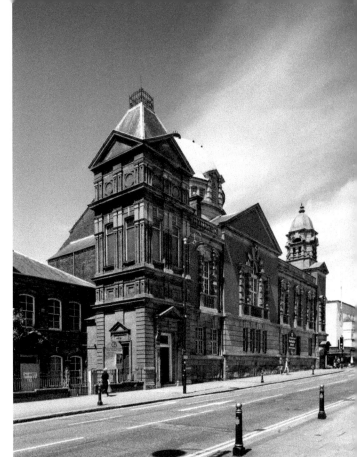

Right and below: Darlington Street Methodist Church, Wolverhampton

In 1825 the existing Methodist congregation moved to a new chapel on Darlington Street. The site had been purchased from the Earl of Darlington. In the 1890s the decision was made to build a new more suitable chapel designed by Arthur Marshall. After the old building closed in 1899 the chapel pictured was opened in 1901 by prominent Methodist Miss Jenks. With its copper dome and twin façade turrets, Pevsner describes the chapel as being 'A very uncommon kind of design for the purpose'. (© Historic England Archive)

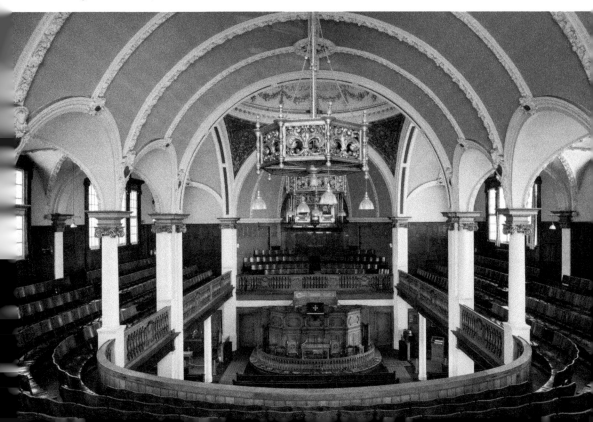

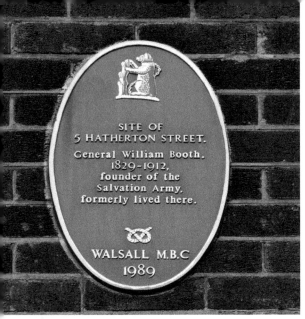

Hatherton Street, Walsall

A blue plaque on a former garage, now a medical centre, marks the position of No. 5 Hatherton Street, where William Booth (later General) was living with his family in 1863. Here he took to marching through the slum areas, collecting people who would be addressed from wagons by reformed reprobates. They were the Hallelujah Band. These ideas would later be developed in the East End of London by William Booth as the Christian Mission, renamed the Salvation Army in 1878. (© Historic England Archive)

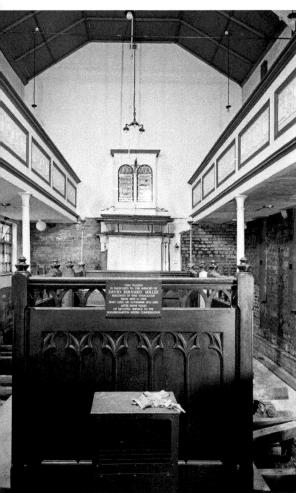

Left and opposite above: Wolverhampton Synagogue, Fryer Street

Fryer Street Synagogue was built in 1858 and opened by the chief rabbi, Dr Adler. A severe fire in 1902 resulted in a major rebuilding in 1903 to a design by architect Frederick Beck. The community was never large, but was swelled by Jewish servicemen stationed at RAF Cosford during the Second World War. After the war the congregation gradually decreased, and the synagogue finally closed in 1999. The building has now been converted into a church. (© Historic England Archive)

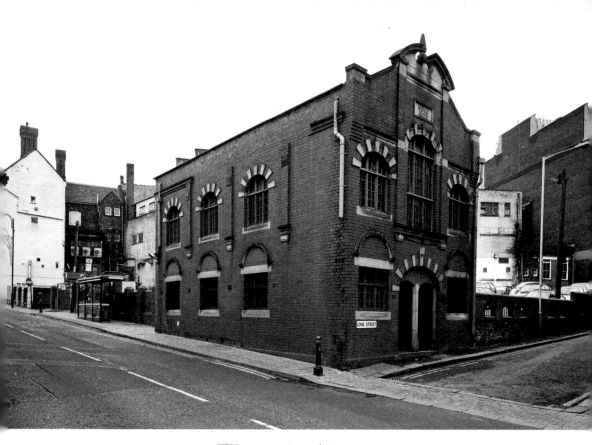

Deanery House, Wulfruna Street, Wolverhampton Deanery Hall, pictured around 1870, was built by Richard Best in 1667 and replaced an earlier manse. From 1692 to 1713 it was home to ironmaster William Wood. By 1833 it was a ladies' boarding and day school. In 1877 it became a Conservative Club, and in 1909 was used by the local Royal Army Medical Core. Deanery House, as it was now called, was demolished by 1925 to make way for the Wolverhampton and Staffordshire Technical College, which opened in 1933, now the University of Wolverhampton. (Historic England Archive)

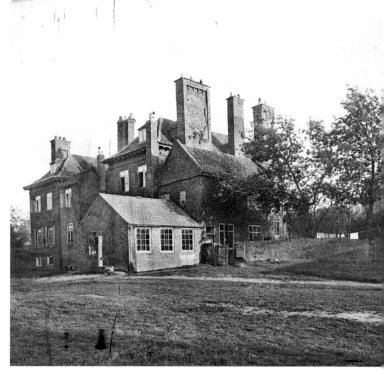

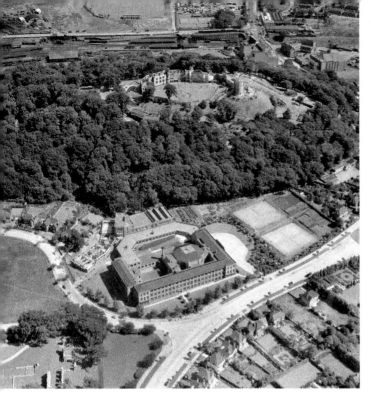

Dudley and Staffordshire Technical College

Now renamed Dudley College, the institution can trace its origins right back to the Dudley Public Hall and Mechanics' Institute established in 1862. In 1896 Dudley Technical School was established in Stafford Street. The Broadway Campus of Dudley Technical College, pictured from the air in 1952, was opened by Earl de la Warr in 1936. The proximity to Dudley Castle behind can be seen, as can the tennis courts to the right, which would later become a car park. (© Historic England Archive. Aerofilms Collection)

Wolverhampton Grammar School

When this picture was taken in 1874 the existing Compton Road School was still under construction. The grammar school was originally founded in 1512 in St John's Street by Wolverhampton-born Sir Stephen Jenyns. He made his fortune in wool and was the Lord Mayor of London in 1508–09. The old grammar school was becoming overcrowded and so a new one was designed in Victorian Tudor Revival style by Giles and Gough of London. The relocated grammar school opened in 1875. (Historic England Archive)

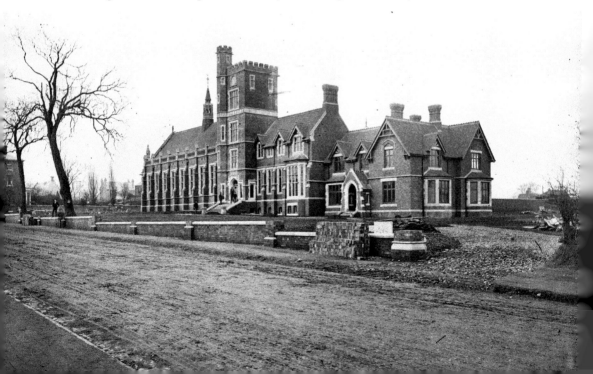

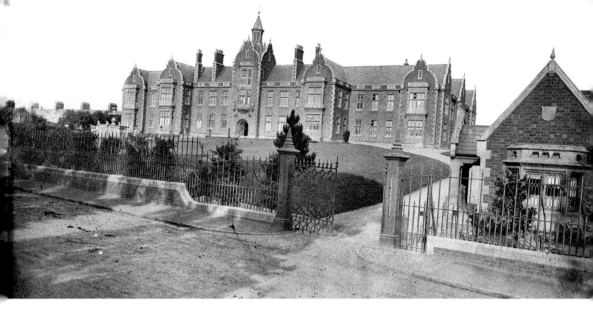

Above: The Royal Wolverhampton School
Viewed here from the Penn Road in 1874, the school was founded in 1850 by local philanthropist John Lees. Originally it was an orphanage, the 'Wolverhampton Orphan Asylum', for children orphaned during the terrible cholera epidemics. It quickly outgrew its Queen Street premises and the building on the Penn Road, designed by Joseph Manning, was paid for by public subscription. It was subsequently enlarged during the later 1800s. In 1900 Queen Victoria granted royal patronage and in 1944 it became the Royal Wolverhampton School under George VI. (Historic England Archive)

Below: St James's School, Dudley
St James's School was built on Salop Street in 1842 next to St James's Church for £490. It was a church school run by the National Society and designed in an ecclesiastical style by architect William Bourne, who had also designed the church. When it was built education was not compulsory, and neither was it free. Children who did attend had to pay two pennies per week. Although it ceased being a mainstream school in 1980, strict period lessons continue to this day as the building was relocated to the Black Country Living Museum. (Copyright Dudley Archives & Local History Service)

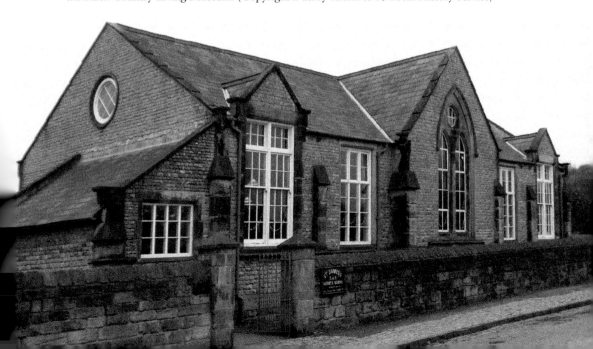

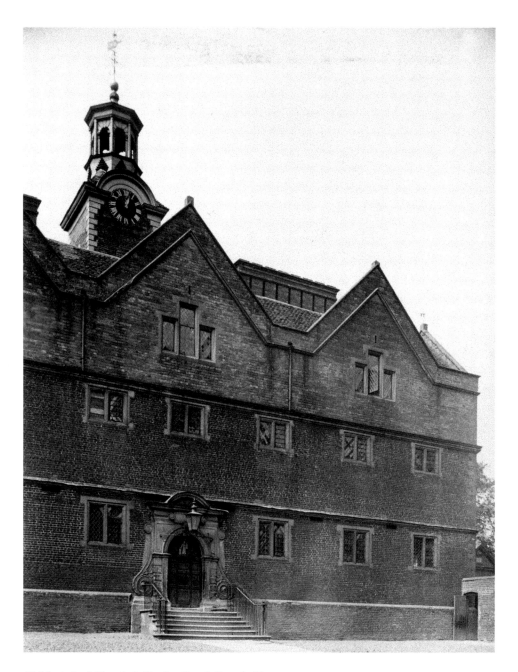

Old Swinford Hospital, Hagley Road, Stourbridge

Despite the name this is now a boarding school. It was established in 1670 by ironmaster Thomas Foley of the Great Witley estate in Worcestershire. Originally, it was a charity school known as Stourbridge Hospital. Foley's intention was to educate sixty boys from 'poor but honest' families in local nominated parishes. After completing their education, the boys would become apprentices. Pictured here before the First World War is the original building and ornate front entrance of the now greatly enlarged school. (Historic England Archive)

Entertainment, Sport and Leisure

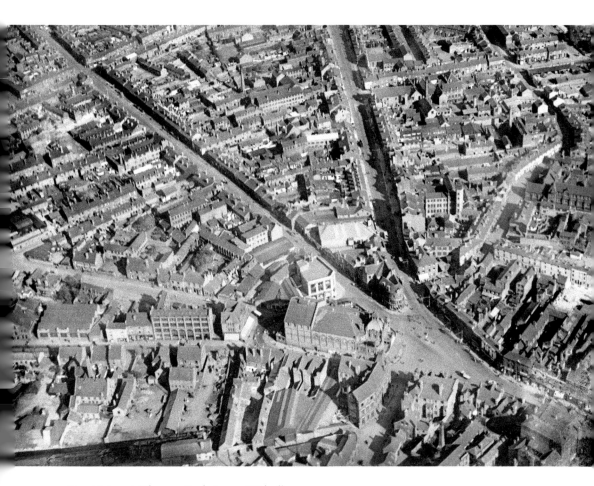

Her Majesty's Theatre, Park Street, Walsall

Pictured in 1928, Her Majesty's Theatre is the large ornate building at the bottom centre. Walsall Theatres Company employed architects Owen and Ward of Birmingham to design the French Renaissance-style building. The theatre was opened in 1900 by the Mayor of Walsall. With changing tastes in entertainment, it became a cinema in 1933, but unfortunately not a successful one. By 1937 the old theatre had been demolished to make way for a new Savoy Cinema, which was itself demolished in 1995. (© Historic England Archive. Aerofilms Collection)

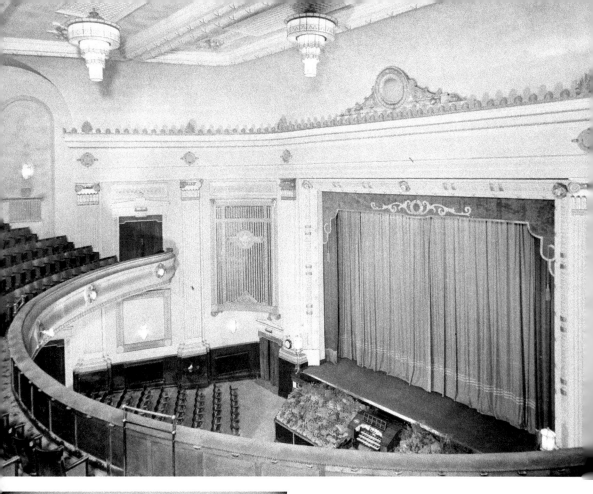

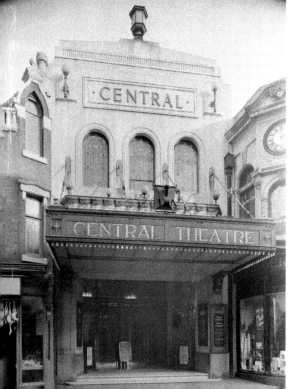

Above and left: Central Theatre, High Street, Stourbridge

Ernest Stevens officially opened the silent cinema in 1929, but by 1930 sound equipment had been installed for the new 'talkies'. Pictured here in December 1937, it had already been acquired by Oscar Deutsch after the death of owner and manager Clifford Bray. It was renamed the Odeon in 1938. The relatively compact frontage belies the fact this was a 1,000-plus-seater cinema. It finally closed in 1973, becoming first a Stringer's store and later Owen Owen. Despite efforts to save it the cinema was demolished in 1995. (Historic England Archive)

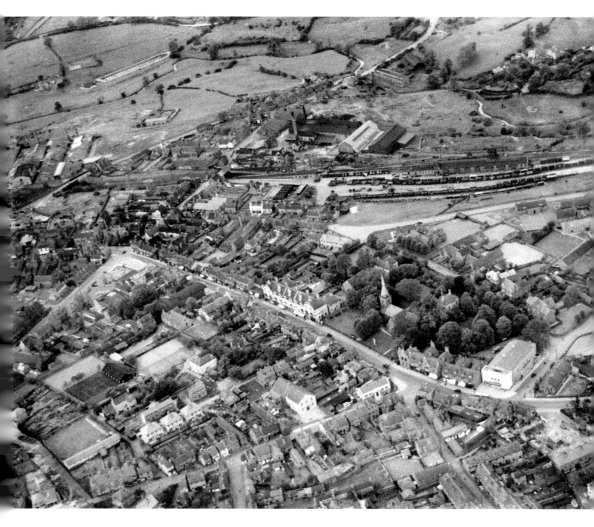

The Clifton Cinema, High Street, Lye
The Clifton is the large rectangular building towards the bottom right of this aerial photograph taken in 1938. In collaboration with theatre proprietor Leon Salberg, Sydney Clift (later Sir) formed the Cinema Accessories Ltd in 1934, which managed the Clifton chain of cinemas. At just over a thousand seats, this was a smaller Black Country Clifton. It opened in 1937, but the end came in 1965, being one of the first local Clifton cinemas to close. The building survives as a supermarket. (© Historic England Archive. Aerofilms Collection)

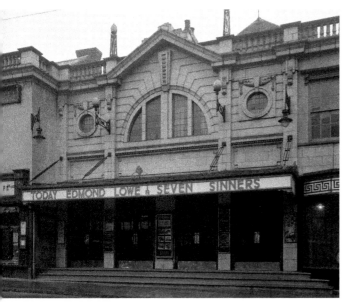

Left and below: Odeon Cinema, Lichfield Street, Bilston
The Wood family had long been associated with cinema presentations, and before the First World War were operating from Bilston Town Hall. It was known as Wood's Palace. In 1921 the Wood family opened a new luxury 1,400-seat cinema in Bilston, also called Wood's Palace. By the end of the 1920s, the cinema had installed the equipment to show sound films. In 1936, on the retirement of Thomas Wood, the cinema became part of Oscar Deutsch's Odeon chain. It closed as a cinema in 1964. The building is preserved as a banqueting suite. (Historic England Archive)

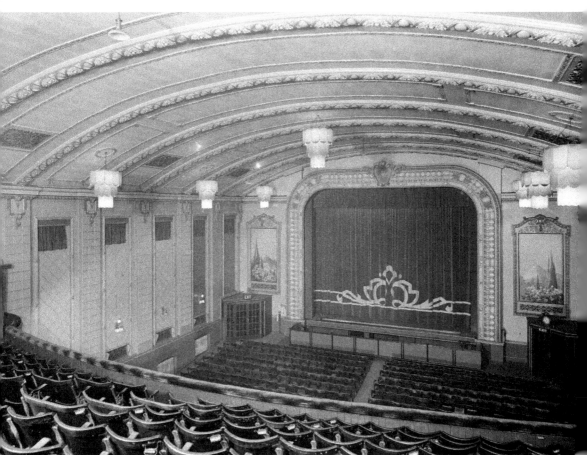

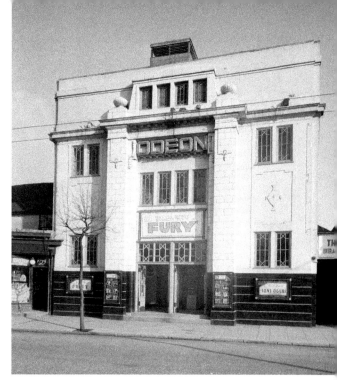

Right and below: Odeon Cinema, High Street, Bloxwich

Formerly the Grosvenor, this was one of the cinemas associated with legendary showman Pat Collins. It was built on the site of a previous cinema, the Electric Palace. Pictured around 1937, by 1935 it was yet another cinema to become part of Oscar Deutsch's cinema chain and renamed the Odeon. It ceased being a cinema in 1959 and suffered mixed fortunes until taken over by J. D. Wetherspoon. It is now the Bloxwich Showman, named in honour of Pat Collins. (Historic England Archive)

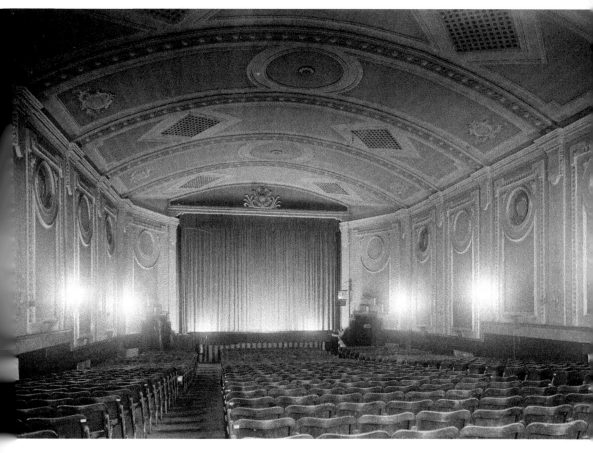

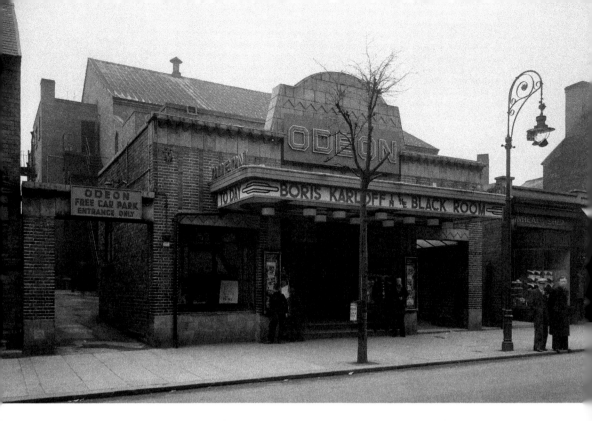

Odeon Cinema, Castle Hill, Brierley Hill
Pictured in 1936, by then the former Picture House was renamed Odeon Theatre. It was the first cinema to be built by Oscar Deutsch, although when it opened in 1928 he was already operating another two. While it was built by Oscar Deutsch, the Odeon name didn't come into being until 1930 with the opening of the Odeon Cinema in Perry Barr. The cinema closed in 1959, and sadly this historic building was demolished to make way for a supermarket. (Historic England Archive)

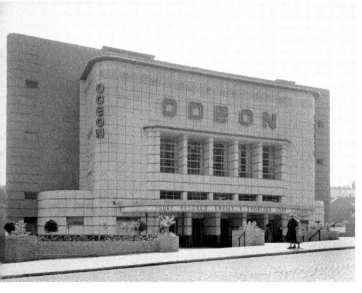

Odeon Cinema, Castle Hill, Dudley
A particularly fine surviving example of an Odeon in the Black Country is the Grade II listed cinema on Castle Hill, Dudley, which closed as a cinema in 1975 and is now used as a Jehovah's Witness assembly hall. Dudley's Odeon was built in 1937 and was designed by the Harry Weedon office. Oscar Deutsch's great innovation was to build his cinemas in a recognisable house style – essentially art deco with curved corners and a symmetrical design. (Historic England Archive)

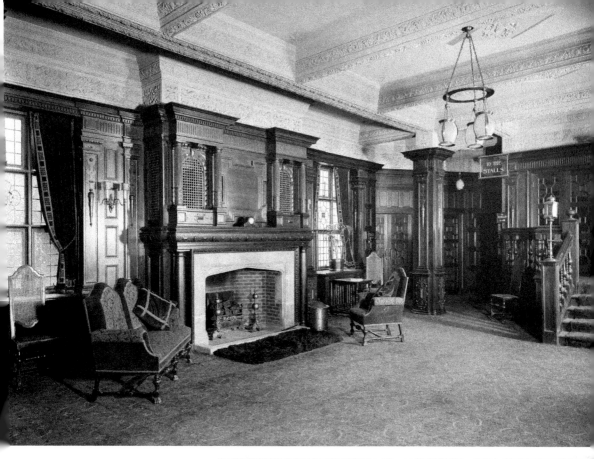

Above and right: The Picture House, Bridge Street, Walsall Pictured just after it opened in 1920, the Picture House was the most luxurious cinema in Walsall. The foyer was made to look like a manor house, having wood panelling and a real fireplace. The auditorium was equally comfortable, with the very best seats being more like armchairs. In 1923 the cinema burnt down, but by 1924 it had been reopened in the same style. It was the first cinema in the UK to have a Wurlitzer organ installed. Renamed the Gaumont in 1948 and Odeon in 1965, the cinema was again destroyed by fire in 1971 and the land redeveloped. (Historic England Archive)

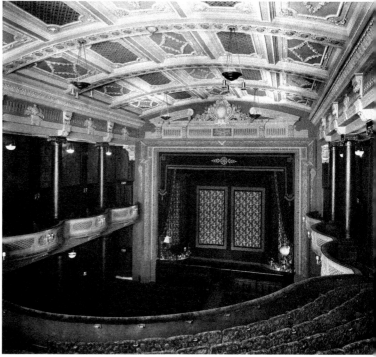

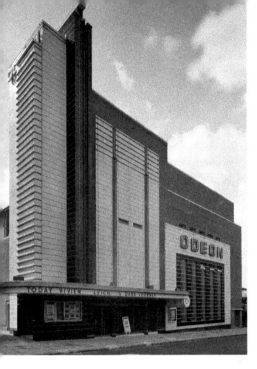

Odeon Cinema, Skinner Street, Wolverhampton
Pictured the same year, the Wolverhampton Odeon was opened in 1937 by the mayor, Sir Charles Mander, with Oscar Deutsch himself in attendance. This was another cinema from the Harry Weedon office, although he wasn't the architect. The cinema could seat just under 2,000 people. By 1973 it had been split into three screens. The cinema closed in 1983 and like so many others it became a bingo hall until 2007. Now Grade II listed, it is currently used as a banqueting suite. (Historic England Archive)

Molineux Hotel, North Street, Wolverhampton
Built around 1720, Molineux became the home of ironmaster Benjamin Robinson. By 1871 the house had become a hotel and the extensive grounds were being used as a park and for sporting events. Bicycle races were particularly popular and in the 1870s crowds of up to 20,000 people would come from all over the country to watch. By 1901 the hotel had been purchased by local brewery W. Butler & Co. By this time the grounds were already being used by Wolverhampton Wanderers Football Club. (© Historic England Archive)

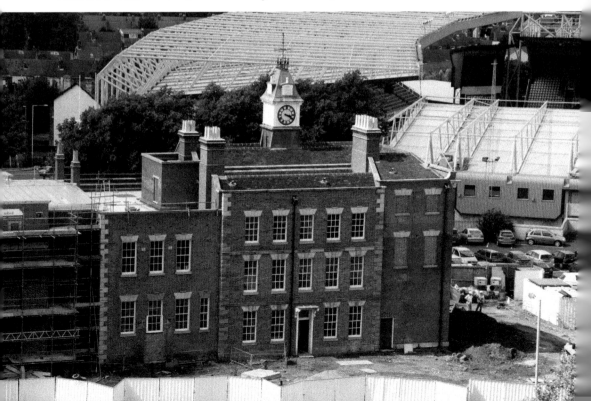

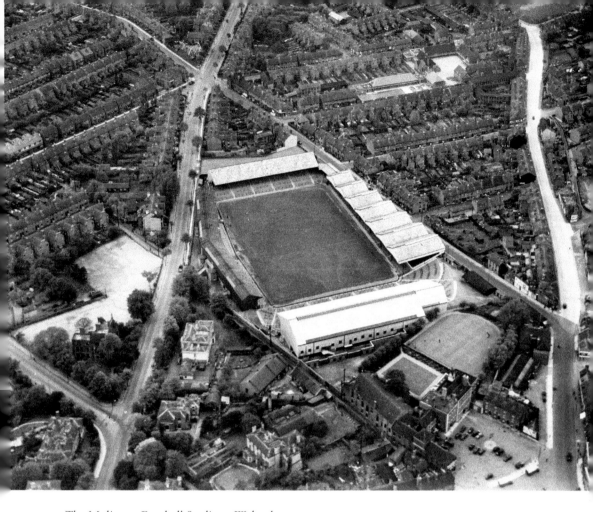

The Molineux Football Stadium, Wolverhampton

Wolverhampton Wanderers moved into the Molineux in 1889. The year before, they had played in the very first English league. By 1923, 'Wolves' were able to buy the ground and set about building a new stand, the Waterloo Stand, designed by architect Archibald Leitch. By 1938, when this aerial photograph was taken, all four stands were in use. A year later Wolves recorded its highest attendance when over 60,000 fans watched an FA Cup match against Liverpool. (© Historic England Archive. Aerofilms Collection)

Hawthorns Football Ground
Centre left of this 1932 photograph is the Hawthorns Football Ground, home to West Bromwich Albion. The ground opened in 1900 with a capacity of 35,000 fans. By 1920 capacity was up to 65,000. In 1937 the highest ever attendance was recorded for a match against Arsenal. In the centre of the picture the Birmingham Railway Carriage and Wagon Works can be seen. (© Historic England Archive. Aerofilms Collection)

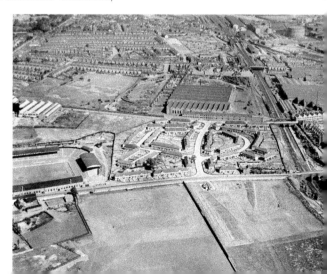

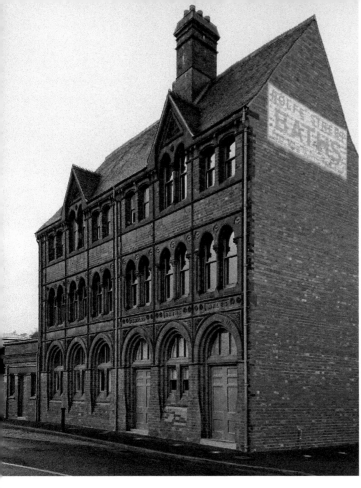

Rolfe Street Baths, Smethwick
Rolfe Street Baths is still fondly remembered by local swimmers. Built by the Smethwick Board of Health, it was designed by Harris, Martin & Harris of Birmingham in red-brick and terracotta panels depicting fish, herons and wildlife. When opened in 1888 it served the dual purpose of providing both washing and recreational facilities. In 1989 the building was taken down, brick by brick, and rebuilt at the Black Country Living Museum. (Author)

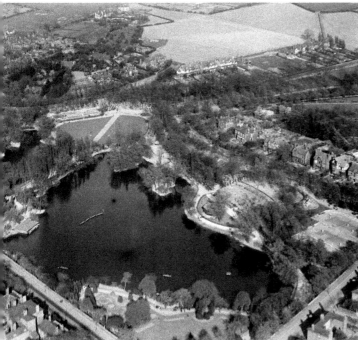

Left and opposite above: The Arboretum, Walsall Formerly the site of extensive limestone quarrying, in 1870 the Walsall Arboretum and Lake Company was formed and leased the land from Lord Hatherton, who gave his name to the lake, which is pictured here in 1926. The Arboretum opened in 1874. Park buildings, including the entrance lodges pictured in the early 1900s, were constructed but the business was not a success. In 1881 the council took over and made the admission free. The Arboretum is well remembered for the famous Walsall Illuminations, which ended in 2009. (© Historic England Archive. Aerofilms Collection; Historic England Archive)

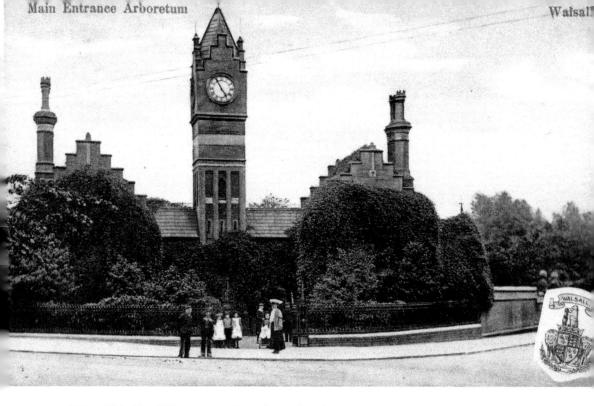

Below: Thimblemill Recreation Ground, Smethwick
The name comes from a former corn mill that was converted to the manufacture of thimbles and was in place until the late 1880s. The mill pool, pictured in the early 1900s, forms part of Thimblemill Recreation Ground created for the employees of Nettlefolds, who manufactured wood screws. A merger with Guest, Keen & Co. in 1902 created GKN. John Nettlefold was a great social reformer who did much to improve the slums of Birmingham. (Historic England Archive)

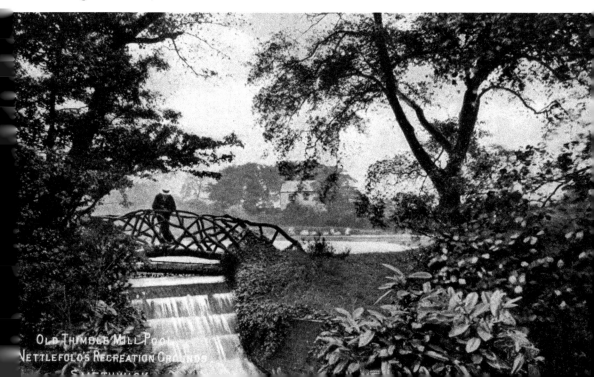

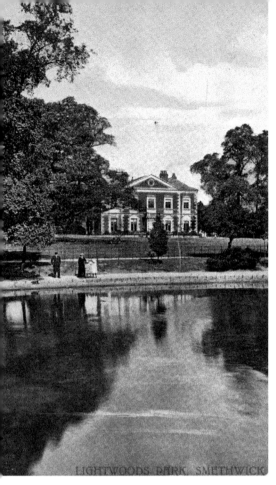

LIGHTWOODS PARK, SMETHWICK

Left and below: Lightwoods House and Park, Smethwick

Lightwoods House and Park was saved from developers in 1902 when A. M. Chance, of Chance Glass, headed up a committee to raise the money to buy it back as a public park. The park and house, shown here around 1904, was presented to Birmingham City Council in 1902 and opened to the public in 1903. Pictured around 1906 is one of two drinking fountains. The money to build them was donated on the stipulation that dogs must also be catered for! (Historic England Archive)

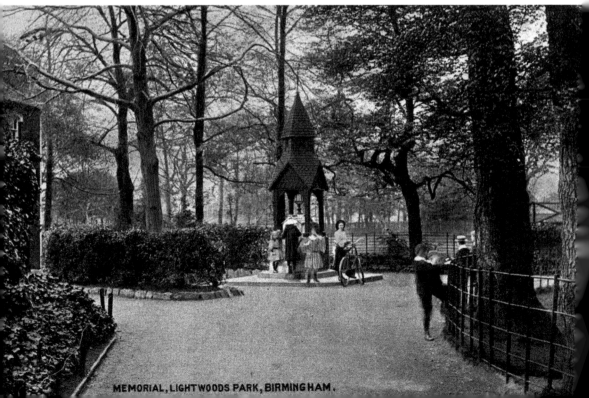

MEMORIAL, LIGHTWOODS PARK, BIRMINGHAM.

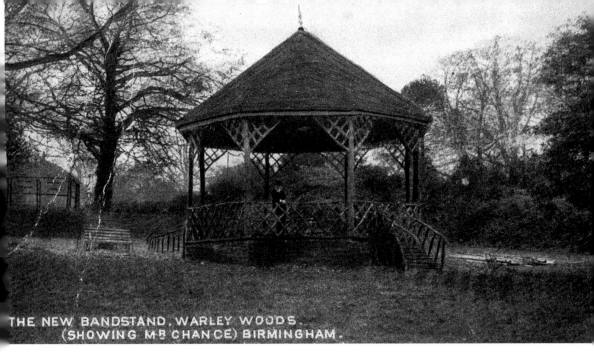

THE NEW BANDSTAND, WARLEY WOODS.
(SHOWING M⁣ʳ CHANCE) BIRMINGHAM.

Above: Warley Woods Bandstand, Smethwick
Having saved Lightwoods Park, A. M. Chance turned his attention to Warley Woods, formerly the Warley Hall estate. A deal was negotiated to purchase the land and the money was raised by mainly public subscription. It opened to the public in 1906. A. M. Chance himself is pictured on the bandstand around the same time. Unusually, the bandstand appears to be a rustic wooden structure rather than the more usual ornate ironwork, perhaps to blend in better with the surrounding woods. (Historic England Archive)

Below: Dartmouth Park, West Bromwich
The park originated when Alderman Reuben Farley wrote to the 5th Earl of Dartmouth saying that a park would be a great boon 'to the hardy sons of toil'. The earl agreed and offered land for Dartmouth Park to be created. It was opened in 1878 by the earl and Reuben Farley with over 40,000 people in attendance. The children, pictured in the early 1900s, are gathered around the drinking fountain. (Historic England Archive)

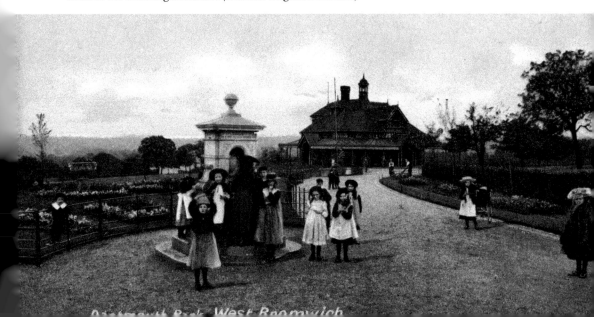

Dartmouth Park, West Bromwich

Above: Brunswick Park, Wednesbury

Brunswick Park was opened in 1887 by the mayor, Alderman Richard Williams JP, in commemoration of Queen Victoria's Golden Jubilee. The 28 acres of land, including a former pit mound, was bought by Wednesbury Urban District Council from the Patent Shaft and Axletree Company for £3,000. Celebrated landscape gardener William Barron was employed to plan the park and the park lodge pictured here in the early 1900s. (Historic England Archive)

Below: Victoria Park, Tipton

Originally conceived by Tipton Urban District Council, this was another park designed by William Barron & Sons. Initially intended to commemorate Queen Victoria's Diamond Jubilee, by the time it opened in July 1901 it was named in honour of Victoria, after her death in January of the same year. The park was developed on an old mining site, with pit shafts and a spoil heap needing to be dealt with. The opening was a grand affair, with the Earl of Dartmouth marching in procession from Owen Street to unlock the park gates. (Historic England Archive)

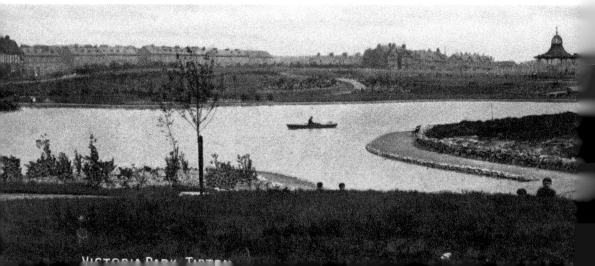

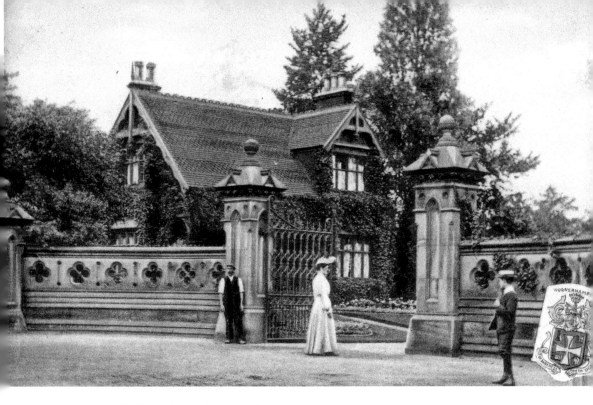

Above and below: West Park, Wolverhampton

West Park was originally the site of a racecourse until it was acquired by the town council to create a park. It was designed by R. H. Vertegans and opened to the public in 1881 by Mayor John Jones as the 'People's Park'. In 1902 the park hosted the Art and Industrial Exhibition, but it ultimately made a loss. Pictured in the early 1900s are the main gates to the park and people enjoying the 8-acre lake. (Historic England Archive)

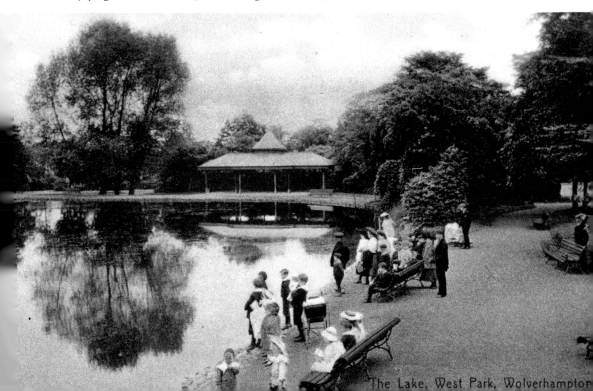

The Lake, West Park, Wolverhampton

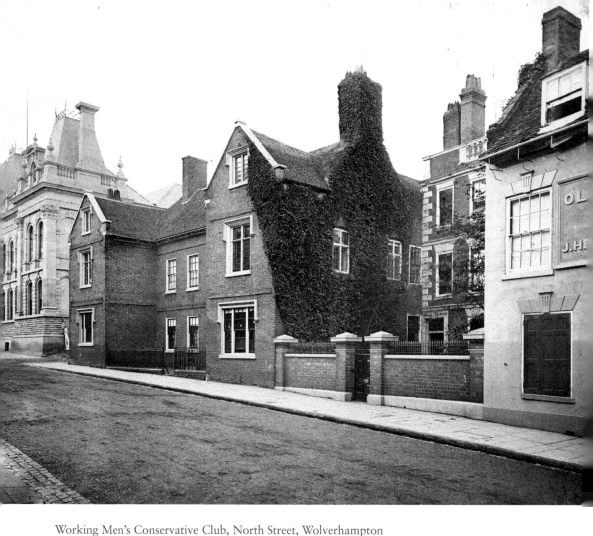

Working Men's Conservative Club, North Street, Wolverhampton

Social and political clubs were very popular in Victorian Wolverhampton, one of which was the North Street Conservative Working Men's Club, pictured here around 1870. The *Evening Express* of April 1884 reported that North Street had 1,200 members. The Labour Party wasn't formed until 1900, but the North Street Club ran its own 'Labour' candidate, shoemaker Abiathar Weaver, in the St Paul's bi-election of 1891. Despite a lack of official Conservative support, Weaver was elected and carried through the streets by jubilant working-class Tories. (Historic England Archive)

Dudley Castle and the Tecton Buildings

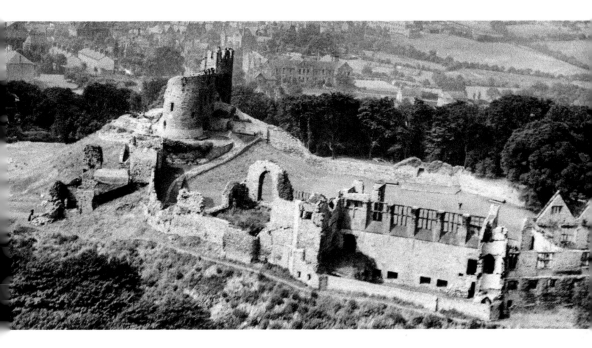

Dudley Castle
This aerial photograph demonstrates the prominent position Dudley Castle has held over the Black Country for centuries. The oldest part of the castle is the keep on the left, while the ruined Sharington Range to the right is a sixteenth-century addition. When this photograph was taken it would be nearly ten years before the famous zoo would be opened. The hilly terrain around the castle illustrates the challenges faced by the architects of the Dudley Zoological Gardens. (© Historic England Archive. Aerofilms Collection)

Dudley Castle Keep
French Knight Ansculf de Picquigny built the first motte-and-bailey castle of earth and wood. In the twelfth century the castle was fortified by the de Paganel family. This was most likely the first stone version of the fortifications. After Gervaise de Paganel was involved in a failed rebellion against Henry II, the castle was partially demolished. After the castle passed to the de Somery family through marriage they continued the fortifications, including the distinctive keep pictured here in 1913. (Historic England Archive)

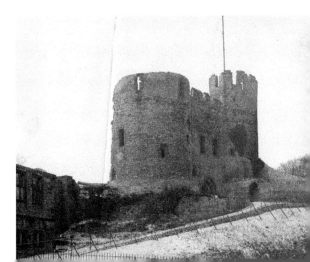

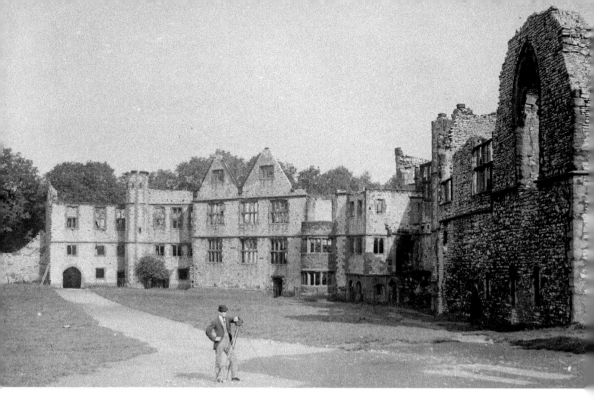

Sharington Range
In the mid-sixteenth century John Dudley undertook a major rebuilding programme, including the Sharington Range of apartments named after the architect Sir William Sharington. A Royalist stronghold during the English Civil War, the castle was later slighted, but the Sharington Range was left intact. By this time the castle was in the hands of the Ward family of Himley Hall. In 1750 the Sharington Range was ravaged by fire, leaving the ruins being photographed here by an Edwardian gentleman. (Historic England Archive)

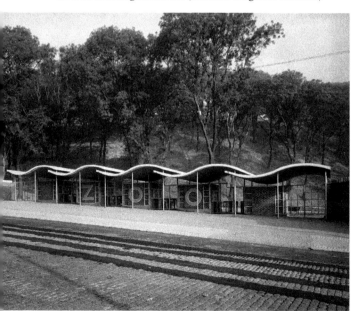

Tecton Entrance, Dudley Zoological Gardens
In the 1930s the Earl of Dudley, William Humble Eric Ward, together with Earnest Marsh and Captain Frank Cooper, created a zoo on the Castle Hill site, which opened in 1937. They chose Berthold Lubetkin and his Tecton Group to design modernist buildings that would fit in with the natural environment of the hillside. The twelve surviving Tecton buildings all achieved World Monuments Fund status in 2009. (Historic England Archive)

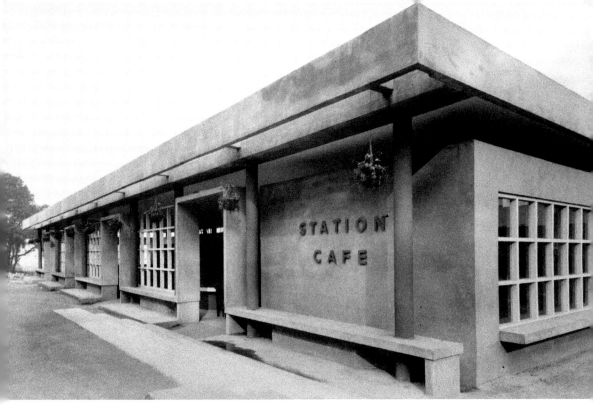

Above and below: The Moat and Station Café
Lubetkin used a new building technique using prestressed concrete tensioned with steel rods, enabling the iconic sweeps and curves of the structures to be achieved. The buildings were constructed in conjunction with a young but influential Danish structural engineer, Ove Arup. The open-fronted moat café (now a glass-fronted education centre), pictured in 1937, characterises these long sweeping curves. (Historic England Archive)

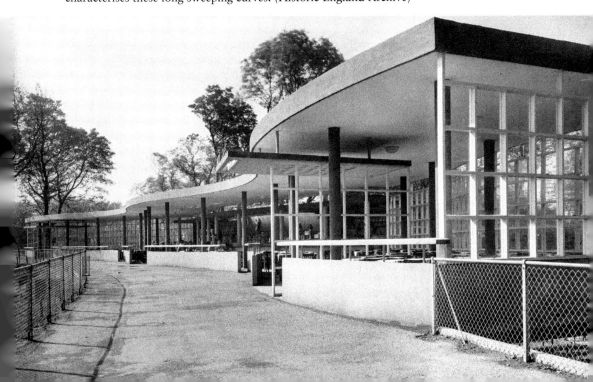

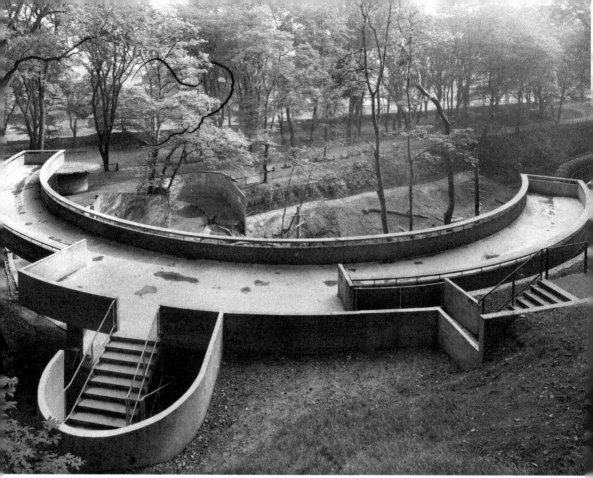

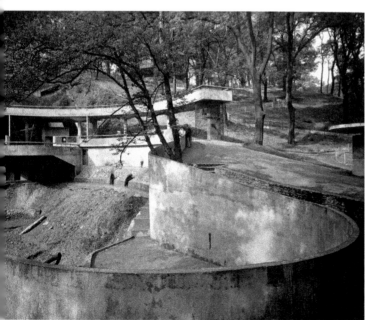

Above and left: Bear Ravine
Lubetkin's vision was to
create a zoo without bars,
providing visitors with an
unrestricted view of the
animals. The Bear Ravine is a
prime example of this where
a naturally occurring ravine
was turned into an enclosure
for brown bears. The large
semicircular amphitheatre
gave visitors an unrivalled
view of the bears below.
(Historic England Archive)

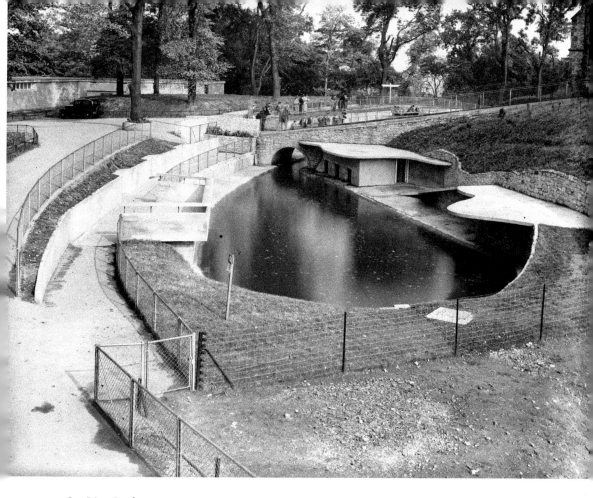

Sea Lion Pools

This 1937 photograph shows how the Sea Lion Pools were built to follow the curve of the castle moat. The old and the new were carefully blended by using local stone for the retaining wall and the bridge. After extensive refurbishment the pools are again fit for their original purpose and continue to house the sea lions. (Historic England Archive)

Penguin Pool

This is the only one of the original thirteen major Tecton buildings not to have survived. The penguins required salt water, which was found to react very badly with the reinforcement rods embedded in the concrete. The corrosion was so severe that the Penguin Pool had to be demolished in 1979. (Historic England Archive)

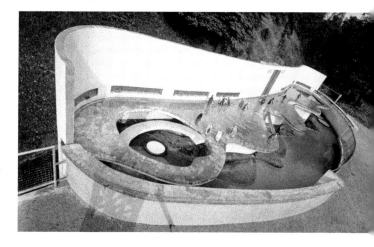

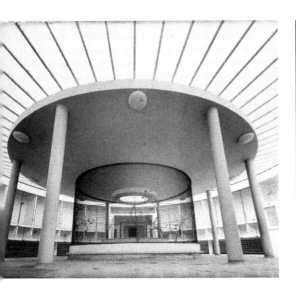

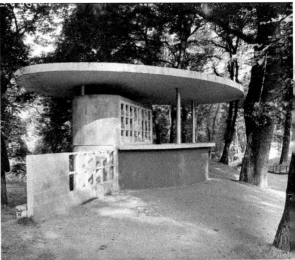

Above left: Inside the Bird House
This two-storey circular building housed tropical birds when pictured in 1937. It was built without windows and the birds were displayed around the walls and in the centre. Light was designed to come from above through the fully circular glazed roof. Heating pipes were passed through the glazing to prevent the build-up of snow in the winter. (Historic England Archive)

Above right: Outdoor Kiosks
The Tecton buildings also include two very distinctive small ice-cream kiosks. The large elliptical concrete roof is held up by metal stanchions. The small concrete store below extends around to form a counter. Unfortunately, the kiosks are no longer environmentally suitable for their original purpose. (Historic England Archive)

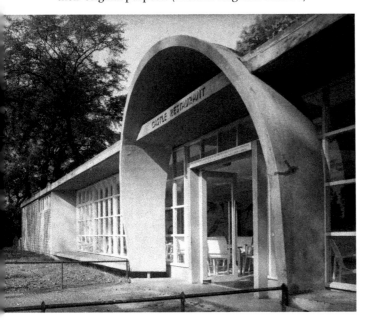

Castle Restaurant
The main formal restaurant for the site was built as a single storey so as not to spoil the view from the castle. The shape was determined by the limestone outcrop it sits on. It was also used for tea dances and evening dinner dances. The internal shape and design resembled an ocean-going liner and so was also known as the Queen Mary Ballroom. (Historic England Archive)

Transport Links

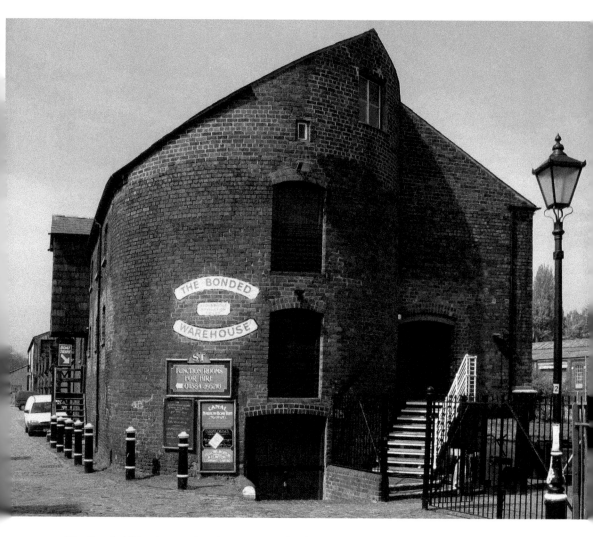

The Bonded Warehouse, Canal Street, Stourbridge
A three-storey building sitting on the wharf of the Stourbridge Town Canal Arm. The building can be dated back to 1799 and the walls are up to 13 inches thick. It was used to securely store taxable goods such as tobacco, spirits and tea brought by canal until the appropriate excise duties had been paid. (© Historic England Archive)

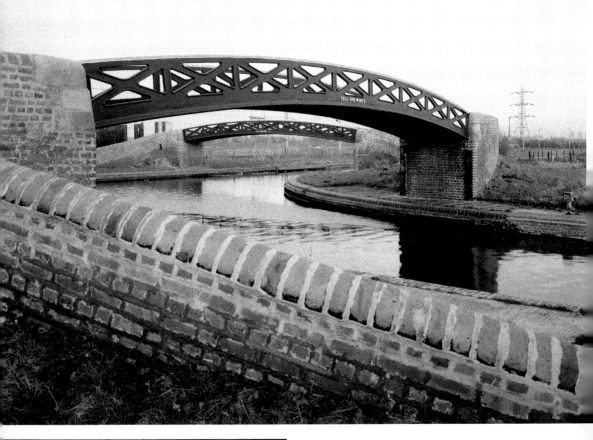

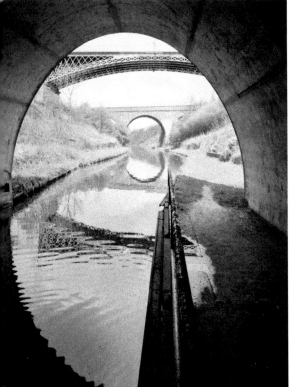

Above: Roving Bridges, Dudley Port Junction

Roving bridges take the towpath over the canal. They are built in such a way that a horse towing a barge can cross sides without getting caught up on the bridge. The Netherton Tunnel Branch opened in 1858 and the bridges were supplied by the Toll End Ironworks, Tipton. Netherton Canal Tunnel was the last one to be built in Britain. (© Crown copyright. Historic England Archive)

Left: Galton Bridge, Roebuck Lane, Smethwick

The Grade I listed Galton Bridge, pictured from the end of Galton Tunnel, was the highest single-span bridge in the world at 151 feet when it was constructed by Thomas Telford in 1829. It spanned the New Main Line Birmingham Canal and was named after BCN committee member Samuel Tertius Galton. (© Crown copyright. Historic England Archive)

Right: Horseley Iron Works

Horseley Iron Works of Tipton cast the ironwork for the Galton Bridge and many others, including this roving bridge at Spon Lane Locks. The company is famed for building the world's first iron steamship to go to sea, the *Aaron Manby*. The prefabricated parts were transported to London by canal and final assembly took place at Rotherhithe before successfully crossing the Channel in 1822. (© Crown copyright. Historic England Archive)

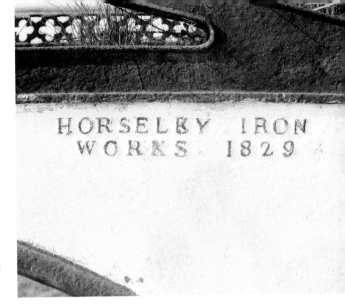

Below: Stourbridge Town Canal Arm

It was here in 1962 that a stand-off took place that was to have repercussions throughout the canal network. A group of dedicated enthusiasts defied the authorities and prosecution in dredging the canal arm themselves and holding a rally, which attracted over a hundred boats and national publicity. The 'Battle of Stourbridge' was a turning point for the fate of the entire canal network. (© Historic England Archive)

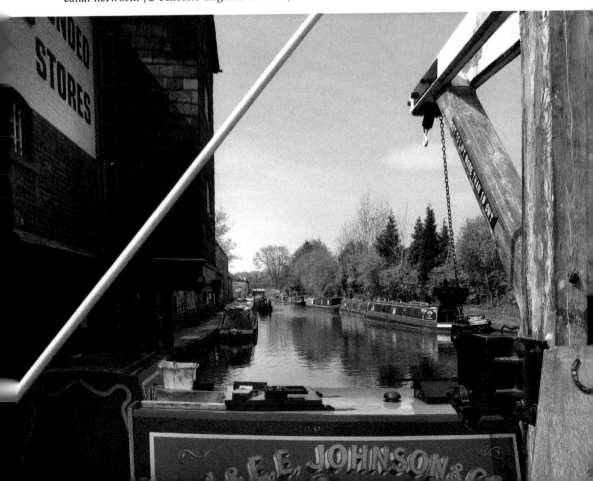

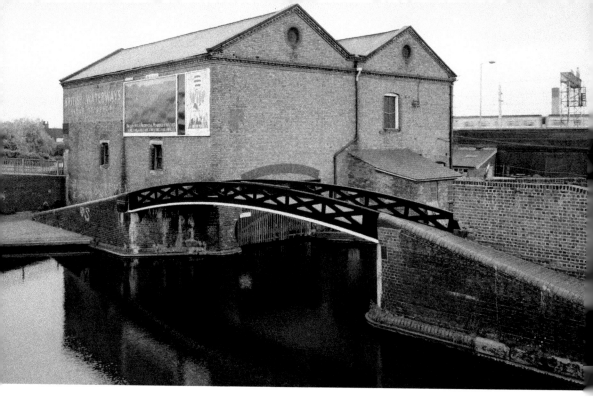

Above: Broad Street Warehouse and Footbridge, Wolverhampton

Broad Street Basin was created when the BCN Main Line canal was diverted in 1849–50 to allow the building of what would become High Level station for the Shrewsbury & Birmingham Railway, which opened in 1852. The Shropshire Union Railways and Canal Company built the warehouse and surrounding buildings in 1870 at the northern end of the original canal, which was now a basin. (© Crown copyright. Historic England Archive)

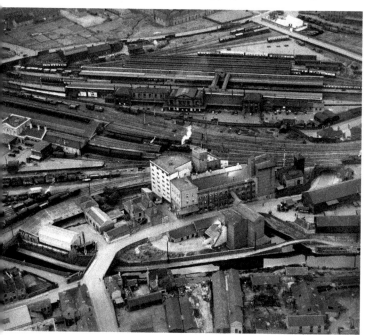

Left and opposite above: Wolverhampton Railway Stations

Taken in 1938, ten years before nationalisation, the LMS High Level station can be seen middle left of the aerial photograph. The rear of the picture is dominated by the GWR Low Level station, shown in 1994 prior to redevelopment. The building in the centre is J. N. Miller's Old Steam Flour Mill. Milling on the site can be traced back to the late eighteenth century, but had ceased by the late 1950s. The mill closed in 1990. (© Historic England Archive. Aerofilms Collection; © Crown copyright. Historic England Archive)

Below: Stourbridge Town Branch Line
This was one of the branch lines listed for closure under the Beeching cuts, but was reprieved in 1965. Opening in 1879, it carried passengers from Stourbridge Town to the main line Stourbridge Junction, but also carried freight to and from the Stourbridge Canal Basin via a bridge over Foster Street, which was demolished in 1967. This left just 0.75 miles of track, making it officially the smallest branch line in Britain. (Historic England Archive)

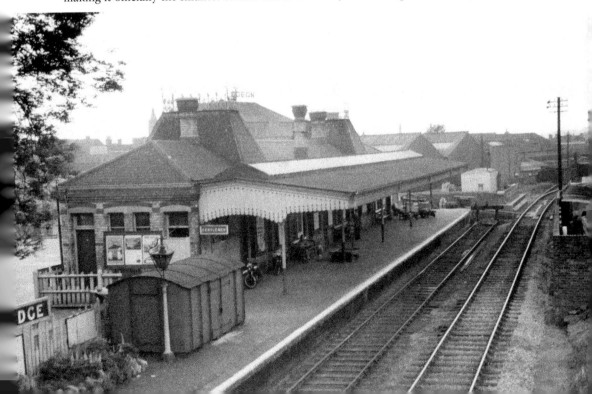

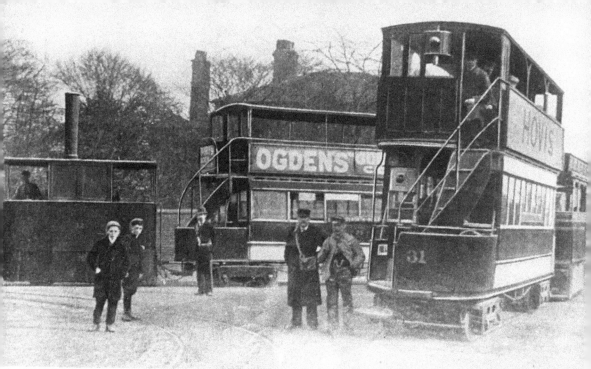

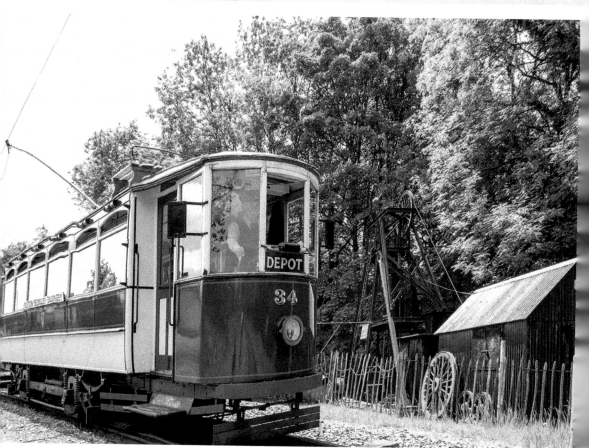

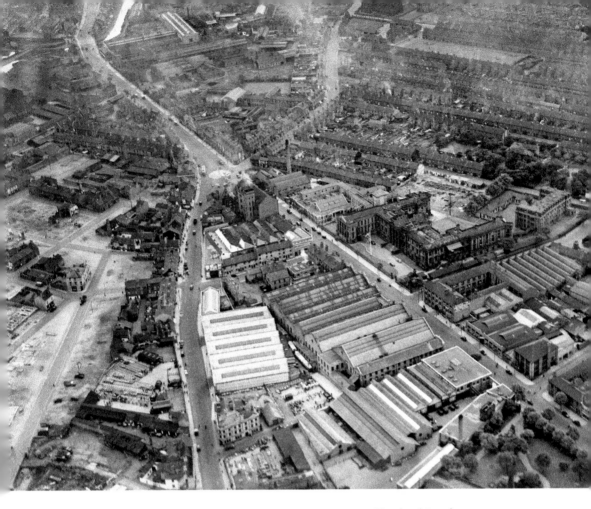

Above: Wolverhampton Corporation Transport Department, Cleveland Road
Pictured in 1937, the Transport Department is in the centre of the picture and the Royal
Hospital is to the centre right. When Wolverhampton electrified their trams, they chose the
Lorain Surface Contact System rather than overhead wires. By 1921 this was replaced by
overhead wires, but by 1928 trolleybuses made by local companies such as Sunbeam and
Guy were connecting throughout the Black Country and beyond. By 1967 these too would be
replaced in favour of motor buses. (© Historic England Archive. Aerofilms Collection)

Opposite above: Steam Trams at Dudley Tram Station
By the mid-1880s steam-powered trams, replacing earlier horse-drawn vehicles, were operating
from Dudley, and by 1890 regular services were running to Wolverhampton and Birmingham.
Taken around 1900, this picture shows a Birmingham and Midland Tramways tram together
with a South Staffordshire Company tram. These services were very soon to be electrified.
(Copyright Dudley Archives & Local History Service)

Opposite below: Overhead Cable-powered Electric Tram
When trams were electrified, most towns went for the overhead wire system, with the notable
exception of Wolverhampton prior to 1921. Pictured is single-decker tram No. 34, built by
Tividale-based Birmingham & Midland Tramways in 1919 for Wolverhampton District Tramways.
Holding up to thirty-two seated passengers, single-decker trams were able to work on routes with
low railway bridges. (Courtesy of the Black Country Living Museum)

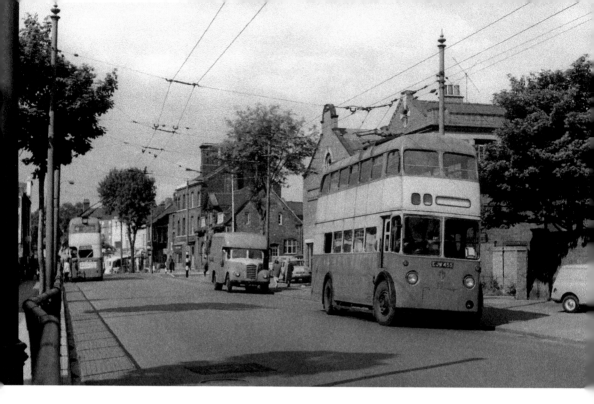

Trolleybuses in Mount Pleasant, Bilston
Trolleybuses proved a great success for Wolverhampton Corporation, so much so they had entirely replaced trams by 1928. Pictured in 1964 is Wolverhampton tram No. 455. This had a typical Sunbeam chassis with a Park Royal body. Despite the popularity, the very last Wolverhampton trolleybus was destined to run on the Dudley route in 1967. (With permission of Wolverhampton Archives)

Bean Car, Hall Street, Dudley
A Bean four-seater tourer outside the Hall Street office around 1920. In 1919, restructuring had resulted in chassis production at Tipton with bodywork and finishing in Dudley. The company changed its name to Harper Bean Ltd. Despite the popularity of Bean cars and motoring in general, financial difficulties forced the company into voluntary liquidation in 1925. Production continued under Hadfield Ltd, but car production eventually ceased in 1929 with the last of the Hadfield Beans. (Copyright Dudley Archives & Local History Service)

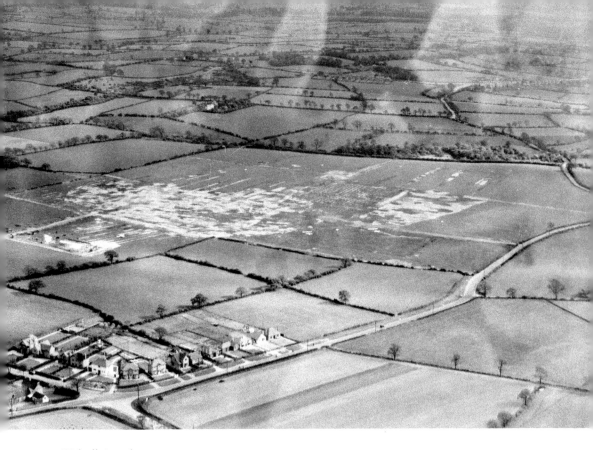

Walsall Aerodrome
Walsall Council had the idea of building a West Midlands regional airport, but it was not to be. By the time this aerial photograph was taken in 1934, a clubhouse had been completed and a hanger was still under construction (centre left). The airfield was mainly used for club and private flying. Dudley-based Helliwells were based there and coordinated war work during the Second World War. After the war the airfield returned to small-scale operations, finally closing to flying in 1956. (© Historic England Archive. Aerofilms Collection)

Steward Aqueduct, Smethwick
A unique location where transport links come together. The aqueduct was built in 1828 by Thomas Telford to carry the Old Main Line Canal over the New Main Line Canal. The Birmingham to Wolverhampton railway line runs alongside the New Main Line Canal. The M5 motorway, supported on piers, towers over all three. (© Crown copyright. Historic England Archive)

About the Archive

Many of the images in this volume come from the Historic England Archive, which holds over 12 million photographs, drawings, plans and documents covering England's archaeology, architecture, social and local history.

The photographic collections include prints from the earliest days of photography to today's high-resolution digital images. Subjects range from Neolithic flint mines and medieval churches to art deco cinemas and 1980s shopping centres. The collection is a vivid record both of buildings that are still part of everyday life – places of work, leisure and worship – and those lost long ago, surviving only in fragile prints or glass-plate negatives.

Six million aerial photographs offer a unique and fascinating view of the transformation of England's towns, cities, coast and countryside from 1919 onwards. Highlights include the pioneering photography of Aerofilms, and the comprehensive survey of England captured by the RAF after the Second World War.

Plans, drawings and reports provide further context and reconstruction artworks bring archaeological sites and historic buildings to life.

The collections are housed in a purpose-built environmentally controlled store in Swindon, which provides the best conditions to preserve archive items for future generations to enjoy. You can search our catalogue online, see and buy copies of our images, as well as visiting our public search room by appointment.

Find out more about us at HistoricEngland.org.uk/Photos
email: archive@historicengland.org.uk
tel.: 01793 414600

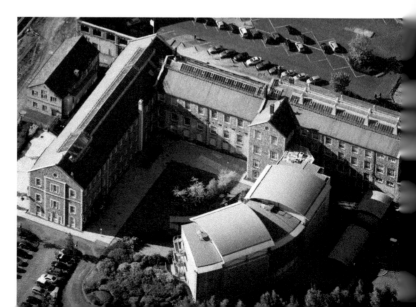

The Historic England offices and archive store in Swindon from the air, 2007.